Susan Applegate
Jay Backstrand
Robert Bibler
Sharon Bronzan
Sandy Brooke
Clint Brown
Karen Carson
Craig Cheshire
Margaret Coe
Jon Colburn
Bets Cole
Jon Jay Cruson
Robert Dozono
Robert Gamblin
Humberto Gonzalez
Dennis Gould
Cie Goulet
George D. Green
John Haugse
Carol Hausser
Jeri Hise
George Johanson
Leland John
Kacey Joyce
Connie Kiener
Edwin Koch
James Lavadour
Nancy Lindburg
Margaret Matson
Sue-Del McCulloch
Gary Meacham
Terry Melton
Kenneth O'Connell
Paula Overbay
Lucinda Parker
Jan Reaves
Laura Ross-Paul
Sandra Roumagoux
Erik Sandgren
Isaka Shamsud-Din
Jim Shull
Susan Trueblood Stuart
Richard Thompson
Hugh Webb
Phyllis Yes

VISUAL MAGIC

An Oregon Invitational

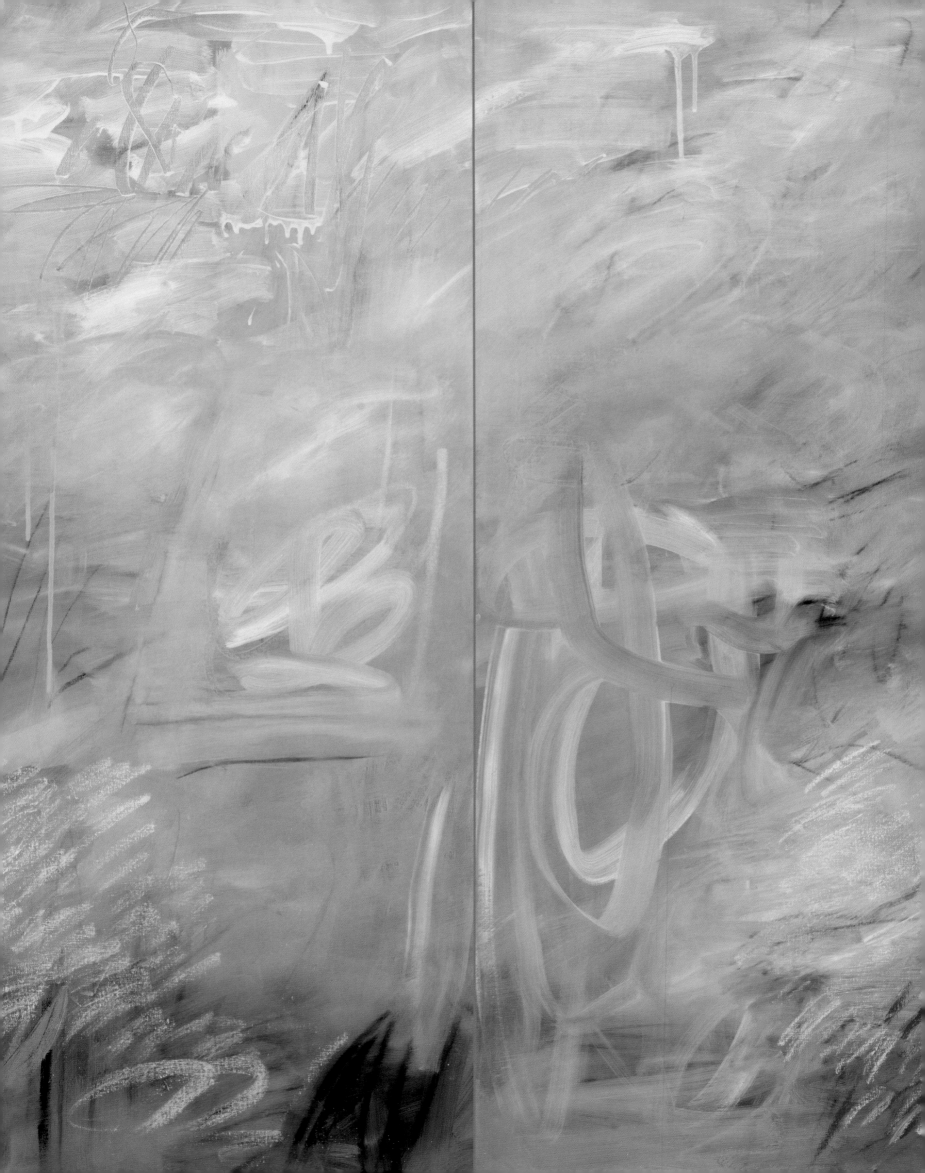

Table of Contents

Cover image: Sharon Bronzan. **Body Guard** (detail), 2018. Gouache on panel, 20 x 16 inches. Courtesy of the artist and Augen Gallery.

Opposite: Sandy Brooke. **Fish at the Door** (detail), 2017. Oil, graphite, and oil stick on linen, 40 x 60 inches. Courtesy of the artist.

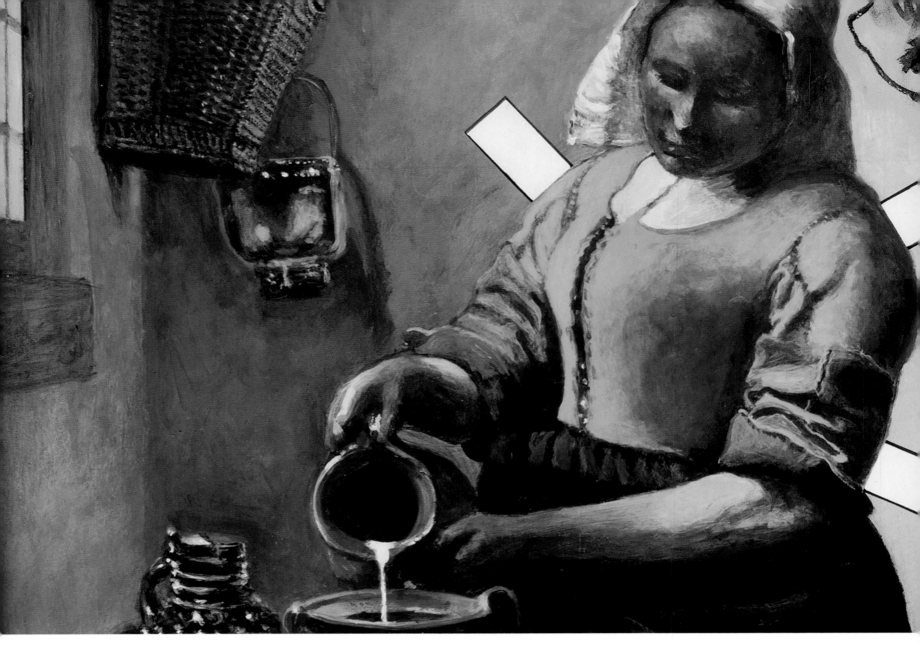

Foreword

JILL HARTZ, *Executive Director*

Few would disagree that the appreciation of art—and art history—changes with each generation. Taste and research bring new attention to artists better known in the past and now rediscovered thanks to some fresh meaning or purpose, while hot favorites today may vanish within a decade or two. Such is the fickleness of the art world.

Painting, as a medium, has found itself endangered, perhaps much to the surprise of its practitioners. Over three years ago, when Hope Pressman and members of the George D. Green Art Institute, based near Portland, approached the JSMA's McCosh Curator, Danielle Knapp, and me with their proposal for an exhibition solely devoted to artists who lived, taught, and painted in Oregon in the 1960s and '70s, my mind turned to Kenneth Clark's 1935 proclamation that painting was dead. Of course, he meant a certain

kind of painting. But then, happily, I recalled Mark Twain's often quoted response to the premature announcement of his passing, "The reports of my death are greatly exaggerated."

Visual Magic: An Oregon Invitational offers a clear affirmation of the vitality and centrality of painting in the twenty-first century. This selection of recent work by forty-five artists draws from an unusual breadth of subject matter, material, and technique, honed from often fifty or more years of serious practice. The exhibition shows us what painting at its best can offer—a certain type of physicality and presence that captures our region and ourselves.

Thanks to OSU-Cascades Distinguished Professor Emeritus Henry Sayre's perceptive essay we can trace the seedling for this expression in the experimentation

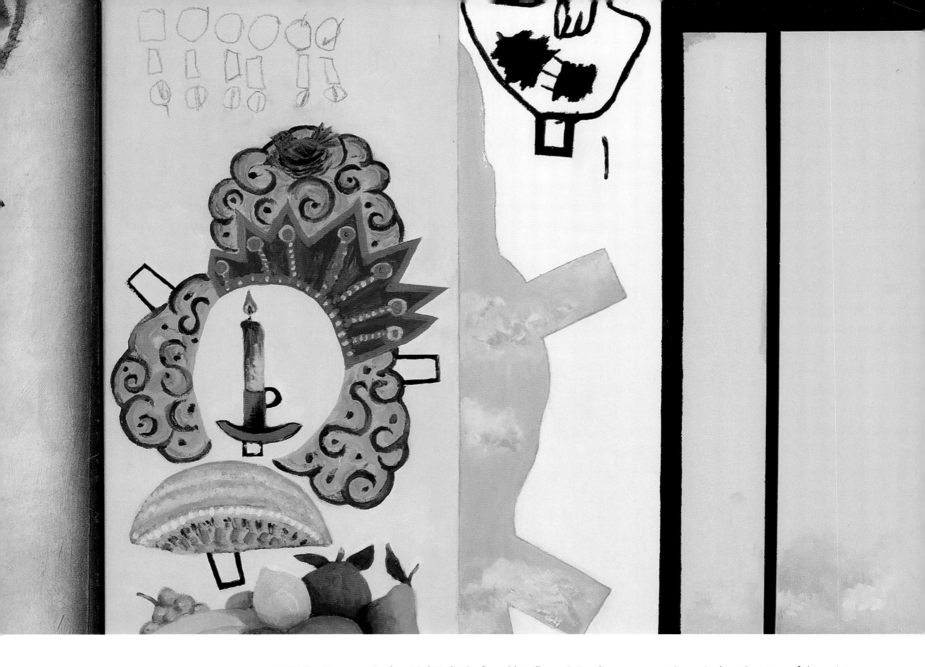

Jeri Hise. **Vermeer Series: Mei Mei's Cyclops** (detail), 2016. Acrylic on canvas, 58 x 70 inches. Courtesy of the artist.

and protests of the 1960s. He reminds us that artists of that time, in painting their inner and outer worlds, were responding to the tragedy and trauma of America and using art, often, to create a better world. From the always insightful Danielle Knapp, who curated this large and significant exhibition, we learn about the artists, their communities and the types of art they made and make, as well as the gallerists and collectors, especially Arlene Schnitzer and Virginia Haseltine, who grasped the power of Pacific Northwest art and kept it close for us to enjoy. The JSMA is committed to collecting, preserving, researching and exhibiting our regional heritage, and to presenting it alongside art from cultures, times, and places throughout the world.

All of us at the museum are indebted to George Green and Jeri Hise as well as others associated with the Institute for proposing this major re-evaluation of

Oregon's painting legacy. They have generously shared their research, suggestions, support, and own work. The exhibition is made possible with the generous support of the Coeta and Donald Barker Changing Exhibitions Endowment, Arlene Schnitzer and Jordan Schnitzer, the Oregon Arts Commission and the National Endowment for the Arts, a federal agency, and JSMA members. We are grateful to the Ford Family Foundation for a 2018 Exhibition and Documentation Support Grant and to the GDGAI's supporters for enabling us to document this project in the accompanying fully illustrated catalog.

Acknowledgments

from
the Curator

Visual Magic: An Oregon Invitational is dedicated to the late Hope Pressman, who provided the initial introduction between the JSMA and the George D. Green Art Institute, making this collaborative partnership possible. Her legacy of arts advocacy continues to inspire. We also honor the memories of painters Edwin "Ed" Koch and Janet "Jan" Reaves, whose works we are proud to present in *Visual Magic*. Ed passed away in May, Hope in June, and Jan, a member of the UO School of Art faculty since 1988, in July this year.

I also offer my deepest thanks to George Green, Jeri Hise, Dan Biggs, Terry Melton, Reagan Ramsey, and their colleagues from the George D. Green Art Institute; Henry Sayre; student interns Maryam Alwazzan, Jacob Armas, Kristen Clayton, Brea deMontigney, and Carolyn Hernandez; Bill Rhoades; Karin Clarke Gallery in Eugene; Augen Gallery, PDX CONTEMPORARY ART, and Russo Lee Gallery in Portland; lenders Abigail Calkin and Seth Koch, Lisa Ford, and Christopher Rauschenberg and Janet Stein; and Robert and Desiree Yarber, trustees of the Morris Graves Foundation, for the opportunity to write my essay during a period of reflection at Morris Graves' final home, "The Lake," in Eureka, California, in September 2018. As always, none of this would have been possible without the ambitious vision of executive director Jill Hartz and the dedicated teamwork of my colleagues at the JSMA: graphic designer Mike Bragg, registrar Miranda Callander, chief preparator Joey Capadona, collections assistant Erin Doerner, assistant preparators Mark O'Harra and Beth Robinson Hartpence, associate curator Cheryl Hartup, Daura Foundation/Margo Grant Walsh curatorial extern Caroline Phillips, photographer Jonathan Smith, assistant photographer Annie Bunch, and communications manager Debbie Williamson Smith.

This project was made possible with a Ford Family Foundation Exhibition and Documentation Support Grant. We are grateful to generous private funding from GDGAI's Benefactors and Sponsors and for their dedication to recording and sharing the work of these incredible artists in an exhibition catalog.

from
George D. Green Art Institute

Benefactors

Sonya McDowell Education Grant

Meri & Scott McLeod

Stephen & Dr. Becky Miller-Moe

Sponsors

Sharon Bronzan

Sandy Brooke

Karen Carson

Barb & Dave Corden

Jon Jay Cruson

Robert & Noriko Dozono

Sandy Green

Dinny Hausser & Lenny Held

Nels Hall & Deb Mawson

Tim Liszt Design

Terry Melton

Ward Family Fund of The Oregon Community Foundation

Annie Painter

Bettsy & Wally Preble

Ned Preble

Jane & Reagan Ramsey

Laura Ross-Paul

Ann Teal, The Teal Family Qtip Trust

Andy Thaler

Visual Magic:
The Oregon Connection

Danielle Knapp, McCosh Curator

A painting has to stand on its own, as each individual has to stand on his own. [...] Many times people look at paintings as having only the content of what it looks like, right away. I think in the long run, what's interesting is what I don't understand right away, or at least I don't see the whole thing right away.[1]

—Robert Dozono, in an interview with Lucinda Parker, 1991

I have been fortunate to curate the University of Oregon's David John and Anne Kutka McCosh Memorial Collection for the past eight years and the Jordan Schnitzer Museum of Art's collection of regional art for nearly as long. With an extraordinary representation of several key Pacific Northwest artists in these holdings (among them, Rick Bartow, Morris Graves, Carl Morris, and many who are featured in *Visual Magic: An Oregon Invitational*) available for close study, I am often engaged in projects that attempt to situate the arc of an artist's career in his or her time. My own research centers on David McCosh (1903-81), an instructor of painting, drawing, and lithography at the University of Oregon from 1934 to 1970. His extraordinary eye for the natural world and work ethic as a painter inspired many, including several artists whose works are included here. In 1965, during his last full decade of teaching, McCosh took a leave of absence to paint in New Mexico and in San Miguel de Allende, Mexico City, and the Yucatan. Stepping away from his professional duties at the University, as he had done on two earlier travel sabbaticals,[2] allowed for a re-examination of his own practice. Just as importantly, these new places and new subjects provided the excitement of fresh visual experiences.

To look at a pivotal period of growth shared among a community of artists sparks a similar sense of discovery and delight. I was honored to be invited by abstract illu-

sionist painter George Green; artist Jeri Hise, executive director of the George D. Green Art Institute (GDGAI); and the Institute's board to help realize their vision of a major contemporary painting show with Oregon of the 1960s and early 1970s as a conceptual starting point. In Dr. Henry Sayre's essay "Visions of Change," which follows, he addresses the long reach of one pivotal year from that period. He sets the scene for understanding the larger forces at work in art, music, politics, and technology in 1968. This is a framework for the state of arts education—not just in the formal academic sense, but in the larger context of the influences, events, and experiences that one likely encountered as an emerging artist in that time and place.

As the University of Oregon's art museum, the JSMA is a site of experimental and experiential learning. Connecting students with original works of art is a core component of the GDGAI's mission as well. This exhibition as conceived by Green, Hise, Terry Melton, and Susan Trueblood Stuart additionally encourages connections between viewers and the artists themselves. The singular visual experience—highly subjective, uniquely personal, and at times challenging, yet endlessly rewarding–is as important as the work of art itself.

This is not new territory for GDGAI. Over three years ago, the Institute launched an ambitious series of ex-

Lucinda Parker. **Retreating Ice** (detail), 2015. Acrylic on canvas, 78 x 60 inches. Courtesy of the artist and Russo Lee Gallery.

hibitions, the first of which was titled *Visual Magic: Handmade Pictures* (September 25 – November 13, 2015). Their selection of paintings, drawings, digital photographs, and prints was exhibited at the downtown campus of Portland's Northwest Academy, a middle and high school college preparatory school. There, students encountered original works by Jon Jay Cruson, Terry Melton, Lucinda Parker, and thirteen other incredible artists in the halls of their own school instead of in an art museum or professional gallery. The Institute itself builds on the personal commitment of its namesake to the dual goals of absolute precision and boundless wonderment. Two additional *Visual Magic* exhibitions organized by GDGAI were presented at Hillsboro's Northwest Regional Educational Service District (*Visual Magic: The Zone of Middle Dimensions*, January 4-February 24, 2017) and the Arts Council of Lake Oswego (*Visual Magic: Robust Exuberance to Contemplative Revelation, 1982-2016*, March 3-31, 2017). Many of the artists who were included in those earlier projects appear in this larger manifestation, *Visual Magic: An Oregon Invitational*.

The discussion of twentieth-century painting in this state typically references a set of important factors, among them, the inspiration provided by the Pacific Northwest landscape – its light, atmosphere, coastline, mountains, forests, and deserts – and its physical and philosophical distance from such artistic centers as New York, Chicago, and Los Angeles. The arrival of C. S. Price in Oregon (although he had worked in Portland briefly in 1910, Price relocated there permanently in 1929) brought an increasingly daring style of modernism to the Pacific Northwest, which he explored until his death in 1950. Oregon's aesthetics shifted and expanded as established artists assumed teaching positions at mid-century; their contributions as educators continue to shape the arts in our state today. However, as Green reflects, "ever since I can remember, clear back to the 1950s, Oregon painting has been mainly Portland painting. When people think of Oregon art, it's mainly Portland art that comes to mind."[3] This invitational seeks to remedy that assumption through a celebration and acknowledgment of the highly original work now produced by artists with early ties to Portland, the Willamette Valley, and elsewhere.[4]

Green, Hise, and I collaboratively assembled a list of artists who paint (many of whom also draw, sculpt, and print) whose careers underwent formative growth in Oregon in the 1960s and early 1970s. This group included many lifelong Oregonians; both self-taught artists and alumni from such programs as the Museum Art School (MAS, now Pacific Northwest College of Art) in Port-

land, Oregon State University (OSU) in Corvallis, the University of Oregon (UO) in Eugene, and the former Mt. Angel College in St. Benedict; and several who studied elsewhere and found their way to Oregon. Of all the formal schools, only the UO offered graduate degrees in art at this time. Gordon Gilkey, who had earned the first printmaking MFA from the UO, became the dean of the new School of Humanities and Social Sciences (later the College of Liberal Arts) at OSU in 1964. During his thirteen-year tenure he assembled a strong art faculty in Corvallis, but students who wished to major in art or earn the terminal degree had to transfer to Eugene to do so. Further north at the MAS, under the leadership of Dean William Givler, many of the state's finest artists came on board to teach. The school achieved accreditation in 1961 and its first BFAs were awarded to the class of 1969.[5]

Although the 1960s and '70s provided the unifying thread in selecting artists, we invited *Visual Magic* participants to share *recent* examples of their painting practice – be it on canvas, paper, board, metal, sketchbook sheet, or ceramic surface. The joy, humor, and whimsy present in many of the pieces on view are balanced by the deep seriousness of these artists' commitments to their work. As Green explains, "Since the '60s [...] here in the Willamette Valley, there have been several clusters of painters pursuing personal visions often with amazing results—but all of them below the radar of the Portland scene. And, consequently, mostly unknown in our state. Several of these artists have branched out into other arenas: LA, San Francisco, Chicago, Texas and New York."[6] He calls this cohort's diverse body of work "home-grown creativity": that is, Oregon-originated ideas that spread around the country through different artistic circles. He continues, "a true history—a complete history—of Oregon painting would include the contributions of painters [from the Willamette Valley], some of whom are historically important on a national and international level. When they are combined with the Portland painters, we will have a more complete history of the painting produced in and nurtured by our state."

Many of the artists exhibited here became influential teachers, dedicated arts administrators, and distinguished advocates for the arts in the decades that followed the 1970s. That they did so while simultaneously advancing their own creative pursuits is especially impressive. When Arlene Schnitzer started the Fountain Gallery in Portland (at which many of the *Visual Magic* artists' works were shown and sold between 1961 and

1986), following her own matriculation at the Museum Art School in the late 1950s, she was cognizant of the challenges for working artists. Richard Thompson recalls how he used to "make pilgrimages" to the Fountain Gallery, which provided his first introduction to contemporary painting and sculpture.[7] "Generations of art students have been raised on the steady stream of important exhibitions by Northwest artists that [were] at the core of the gallery's program," contemporary art curator Bruce Guenther remarked on the occasion of the gallery's twenty-fifth anniversary. "Choosing to focus primarily on Pacific Northwest art, [Schnitzer] met the challenge of providing a home for these artists and encouraging their growth."[8]

Creative and professional growth sometimes required leaving the state. Craig Cheshire, who completed his MFA under David McCosh at the University of Oregon in 1961, traveled to Canada, Mexico, and Europe after graduation before returning to the Pacific Northwest. Many of the paintings from his extended stays abroad, including in Florence, Italy, and Almuñécar, Spain, were exhibited at this museum in 1965.[9] Several *Visual Magic* artists enrolled in graduate programs as wide-ranging as the Munich Academy of Fine Arts, the Pratt Institute, and the San Francisco Art Institute. George Green spent thirty years and Jeri Hise six years in New York City before they relocated to the Portland area in 2006. Others, including Corvallis-raised Karen Carson, never moved back; after earning her BA from the University of Oregon and MFA from the University of California Los Angeles in 1971, Carson commenced a long career teaching and exhibiting around the country and now divides her time between California and Montana. This migration of artists from Oregon in the 1960s and early '70s engendered an ever-expanding web of influence, which still resonates today.

In the 1960s, the Jordan Schnitzer Museum of Art (then the University of Oregon Museum of Art) embarked on its own new direction. It originally opened as a museum of Asian art in 1933 and had not veered significantly from that focus in its first several decades of operation, but the influence of Portland writer Virginia Haseltine and her collaboration with museum director Wallace Baldinger changed this. In Haseltine's essay for the 1963 catalog of the exhibition that publicly debuted her impressive private collection (which was gifted to the museum soon after), she wrote of her definition of "Northwest," "We include not only the [Oregon]-born artists and craftsmen but those who have studied or worked professionally in their area for a few years."[10] Not long after, UO alum Dennis Gould began work as the State-wide Services coordinator for the museum's new traveling exhibitions program, which circulated high-quality art shows free of charge to regional venues. Gifts from Haseltine included paintings by *Visual Magic* artists Gould and Jay Backstrand, as well as their contemporaries Al Goldsby, Henk Pander, Sherrie Wolf, and the late Mark Clarke, to name just a few. The JSMA's collection and exhibition programming has continued to incorporate ever more diverse expressions of the Pacific Northwest experience. Haseltine's and her colleagues' dogged pursuit of the best of regional artistic expression in the 1960s still guides and inspires this endeavor.

Hope Pressman had served on the Friends of the Museum and the Governor's Planning Council for the Arts and Humanities with Haseltine. In 1974, Pressman and sculptor Jan Zach, a member of the UO art faculty since 1958, organized the Oregon International Sculpture Symposium to bring world-class sculptors to Eugene. The following year, Oregon instituted "Percent for Art" legislation in Marion and Polk Counties.[11] One percent of the direct construction funds of new or remodeled state buildings with construction budgets of $100,000 or more were to be set aside for the acquisition of art work. This law extended to the rest of the state by 1977. Painter Nancy Lindburg served as Executive Director of the Salem Art Association from 1973 to 1978 and then took up a new post as Artist Services Coordinator for the Oregon Arts Commission. There were increasingly new opportunities for artists to see one another's works in public spaces and to distribute their own work around the state.

Early in planning for this project, I revisited the catalog for George Johanson's *Equivalents*, his eighty portraits of artist-friends completed between 1999 and 2001. The series includes nine of the artists whose works are presented in *Visual Magic*. I was particularly moved by Johanson's statement in the catalog:

> *These portrait drawings as a group also represent an homage to the artist as worker. Some of these artists are better known than others. Yet all of them share one thing: whether they sell well or not, they persist in their work. They keep on making artwork year after year. Art is done in private but it ultimately has a community component. There is a critical-mass effect at work, which makes the art stronger when there is a lot of it going on. The artist benefits by working in an environment where serious art is being produced, and the public comity is enriched by having so many artists in its midst.[12]*

This thought perfectly captures the environment we hoped to recreate in *Visual Magic*. There is a balance of observation, imagination, and experimentation in the works on view. To paraphrase a thought from Robert Dozono's statement prefacing this essay: The most meaningful appreciation of a painting will require both spending time with the work and spending time thinking about it, revisiting it, after the initial encounter. Formal comparisons between the paintings are not necessary; nor is the academic rigor of a strictly art historical approach. Here, we present the opportunity to enjoy this collection of works one by one, for the singular experience each presents – and more holistically, as a snapshot of the current status of painting in (and in some cases, beyond) Oregon by artists who have been actively "moving the needle" for fifty years. The results are exciting, robust, important, and wildly individualistic.

This invitational was not organized around any themes related to subject matter, but it was not surprising to see many common threads emerge. Ed Koch's succulent nectarines, Phyllis Yes's exquisite lilies, and Nancy Lindburg's still life "in flux" demonstrate a range of approaches to the genre. Throughout the exhibition, artists demonstrate how travel and new experiences have been translated into visual sensations. Susan Applegate navigates both physical and emotional space in work made during a recent Morris Graves Foundation Residency in Eureka, California. Robert Gamblin's quadripartite study of Amsterdam is executed in the colors of Old World Europe, vermillion, Prussian blue, and Delft blue, a nod to the city's rich history and dynamic present. A collection of sketchbooks from Ken O'Connell are delightfully diaristic, but instructive, too; their pages reveal his itinerant experimentation in watercolors, markers, watercolor pencils, and other media.

Others look closer to home for their inspiration. Craig Cheshire, Jon Jay Cruson, Humberto Gonzalez, Leland John, James Lavadour, Gary Meacham, Jim Shull, and Susan Trueblood Stuart are among those who present highly original visions of our shared region. Personal knowledge of the land and coast inform many of these works. Mt. Hood appears like a familiar friend in Lucinda Parker's paintings; still, her cubist exploration of its iconic form opens new pathways to appreciating it, making the old new again. Cie Goulet, a pioneering photorealist painter early in her career, pulls from both memory and imagination to make paintings that are untethered to specific locations. Sue-Del McCulloch grew up in eastern Oregon and has spent most of her adult life in the Willamette Valley. In her artist statement for this show, she offers an explanation for the enduring appeal of landscapes: "At some level, many of us still respond to landscape, seeming to retain a longing for that connection, an echo of our ancient place in nature."[13]

Visual Magic paintings also encourage a voyage of the imagination. The dramatic or absurd scenarios painted by Clint Brown, Jon Colburn, and Hugh Webb invite viewers to look more closely and question their first impressions. Webb was introduced to Bay Area Funk Art during a trip to San Francisco in 1969 and he incorporates a similar irreverence and good humor in his current work. For Rob Bibler, the surreal possibilities presented by cinema mesh fantastically with a contemporary reading of Renaissance influences. Paula Overbay's small imagined worlds seem to capture both the microscopic realm of the cell and the expansiveness of the universe in one blink. Laura Ross-Paul's figures emerge from mystical environs, creating connections between the physical and psychological. World folklore and mythical archetypes inform Sharon Bronzan's ap-

Paula Overbay. **Gyration** (detail), 2017. Acrylic on wood, 22 x 28 inches. Courtesy of the artist.

proach to visual storytelling, as part of a process she describes as "[giving] order to a world I find chaotically complex."[14]

In addition to formal concerns, many of the works in *Visual Magic* confront environmental or social issues. Isaka Shamsud-Din, a muralist and studio painter, gathers images from historical photographs, primary sources, and personal history to expose the fraught realities and deep complexities of racial injustices in the United States. Robert Dozono recycles—or "upcycles"—his personal garbage as the surface for paintings of otherwise pristine waterways. Sandra Roumagoux cleverly inserts images of discarded tires in the place of animal life, a reminder of our natural habitats' precarious state. Climate change concerns are addressed in brilliantly colored, energetically painted diptychs by Sandy Brooke. For both Jeri Hise and Margaret Coe, the narratives of canonical western art history spark new ways of thinking about archetypes and the artist as witness to history. As a student at Smith College, Hise was drawn to the Rare Book Room, where she had access to cuneiform tablets; additionally, her time spent studying seventeenth-century science and the works of Rembrandt, Vermeer, and Leeuwenhoek informed her understanding of connections between the past and present. This gathering, processing, and reinventing of art historical influences feed into the stunning works she now paints in Oregon.

Many of these artists cause us to rethink the perceived limits of their materials. Carol Hausser makes watercolor compositions that seem to defy the fluidity of the medium. Her crisp, overlapping shapes and variations on textures look like a photographic collage at first glance. Bringing paint into the third dimension are Connie Kie-

ner and Margaret Matson, who transform ceramics and paper, respectively, into dreamlike objects. The elegantly sparse acrylic paintings of Kacey Joyce dovetail with her expertise in reduction color linocuts and demonstrate what the flexibility of paint makes possible. In the examples on view by John Haugse, Jan Reaves, and Erik Sandgren, lush colors provide a sense of vitality. Jay Backstrand, Karen Carson, Dennis Gould, and Richard Thompson, through surprising juxtapositions and bold compositional structure, challenge us as viewers. From Bets Cole's small travel vignettes to the richness of Terry Melton's color fields to the enormous *trompe l'oeil* canvases by Green, *Visual Magic* overwhelms the senses.

The participants each contributed statements, gathered at the conclusion of this book, that share personal insights into their practice. In addition to looking to the shared beginnings of these artists and celebrating the diversity of experiences that led to their present-day work, *Visual Magic* is also inspired by forward motion. UO students from the College of Design's Department of the History of Art and Architecture were tasked with researching the *Visual Magic* artists and preparing interpretive materials for the exhibition's presentation at the JSMA, including wall labels and teaching guides, to offer additional perspectives on the works. Thanks to their efforts, new connections and new moments of understanding will take place. I am deeply indebted to these students and to the forty-five artists who offered their works and their stories to make this exhibition possible. All have performed the "visual magic" that first inspired the GDGAI's exhibition series over three years ago and has been a natural product of the artists' fifty years of work.

George D. Green. **The Science of the Angels: Part II – Quatuor pour la fin du temps**, 2017. Acrylic on panel, 48 x 80 inches. Courtesy of the artist.

Visions of Change

Dr. Henry Sayre, Distinguished Professor Emeritus of Art History,
Oregon State University-Cascades

Looking back now, fifty years later, it seems clear that 1968 was a pivotal year. It was a moment of extraordinary change, of often-radical reassessment of social, political, and—it follows—*aesthetic* realities. The artists in this exhibition lived it.

In 1968, many had either recently graduated from or were attending as graduate or undergraduate students the University of Oregon and/or Oregon State University. A few were graduates of the Museum Art School (today Pacific Northwest College of Art, or PNCA), and a few others migrated to Oregon or began painting on their own at the end of the '60s and the beginning to the '70s. But they all felt the same sense of change that was upon them.

That year, on January 5, in Czechoslovakia, Alexander Dubček was elected First Secretary of the Communist Party, inaugurating the Prague Spring, a brief moment of democratization and liberalization, "socialism with a human face," as Dubček called it. Soviet tanks and half a million troops would smash that face in the following August. On January 30, Viet Cong troops invaded Saigon in the Tet Offensive, shattering the myth that the United States was winning the Vietnam War. On April 4, Martin Luther King was assassinated. By the third week of May, 10 million Frenchmen, roughly two-thirds of the French labor force, went on strike in support of students at the Sorbonne, closing the country down. On June 6, in Los Angeles, Bobby Kennedy was shot and killed. Five days after the Soviets invaded Czechoslovakia, on August 26, the Democratic Party opened its national convention in Chicago, and two days later, the police, without apparent provocation, began clubbing every demonstrator they could lay their hands on in Grant Park, across from the Chicago Hilton. For the first time, television cameras broadcast the assault *live*, rather than taking the time to edit or process the footage, as the crowd chanted, "The whole world is watching! The whole world is watching!" On October 16, after winning gold and bronze medals in the 200 meters at the Summer Olympics in Mexico City, sprinters Tommie Smith and John Carlos raise their black-gloved fists in a Black Power salute at the medal ceremony. Finally, on December 24, astronauts William Anders, Frank Borman, and James Lovell, the first humans to escape Earth's gravity, read the first ten verses of Genesis in a special Christmas Eve television broadcast as they orbited the moon. At the time, it was the most watched television program ever. When Anders snapped a photo of the "Earthrise" over the horizon of the moon, he felt, he would later say, that the astronauts were not so much exploring the moon as they were discovering Earth. All of these extraordinary events played out to a musical accompaniment that included Paul Simon's soundtrack album for Mike Nichols' film *The Graduate* (the film was released on December 22, 1967, the album a month later); the soundtrack album to Stanley Kubrick's *2001: A Space Odyssey*—notably Strauss's *Also sprach Zarathustra* and Györy Ligeti's *Atmospheres*—which premiered on April 2, two days before King's assassination; the Beatles' "Hey, Jude," released the day the Chicago Convention opened, just as, simultaneously, Steppenwolf's "Born to Be Wild," the "heavy metal thunder" of which would accompany Peter Fonda and Dennis Hopper as they hit the road the following summer in the opening sequence of *Easy Rider*, peaked at number two on the *Billboard* charts; and, although it was released a year earlier, Aretha Franklin's "Respect," which had assumed its status as the anthem of the Civil Rights and burgeoning feminist movements.

In the arts, Andy Warhol was shot by Valerie Solanis on June 3. Across the Brooklyn Bridge in a small apartment near the Pratt Institute, 22-year-old Robert Mapplethorpe, not yet a photographer, was "very upset about it," his then lover Patti Smith recalls. "He loved Andy Warhol and considered him our most important living artist. ... documenting the human mise-en-scène in his silver-lined Factory."[15] In September, Robert Smithson published "A Sedimentation of the Mind—Earth Projects" in *Artforum*, illustrated by his *Non-Site (Slate from Bangor)* beside a photograph of the Bangor Quarry with the caption "Slate site in an un-

contained condition before being contained in a Non-site by Robert Smithson."[16] Two years later, he would construct *Spiral Jetty*. The father of Conceptualism, Marcel Duchamp, died on October 3—the end of an era—and the beginning of one, since a few months later it was revealed that he had secretly constructed the installation *Étant donnés* at his studio at 210 West 14th Street in Greenwich Village. Two years later, Octavio Paz's *Marcel Duchamp or the Castle of Purity*, an extended analysis of Duchamp's *Large Glass* (in which he quotes Duchamp as saying "today painting is vulgarized to the utmost degree"[17]) would sweep through the UO's undergraduate and graduate population. Also in October 1968, Lucy Lippard organized a show at the Paula Cooper Gallery, which had just opened at 100 Prince Street in SoHo, in support of the Student Mobilization Committee to End the War in Vietnam, for which Sol LeWitt, who to this point was known for his modular constructions, made his first wall drawing. "LeWitt's transposition of his drawings from the restricted if traditional format of a sheet of paper to the architectural space of a wall with which it became absolutely identified was a radical move," Bernice Rose later wrote, in transforming "the way in which the thing is made," it equally transformed "expectations of the way art ought to look—what it ought to be."[18] Having abandoned her studio in New York the previous year, Agnes Martin arrived in Cuba, New Mexico, and began building an adobe studio for herself. She would not take brush to canvas again for five years. And in Los Angeles, John Baldessari was completing a set of works depicting the most unremarkable sites in Los Angeles, black-and-white photographs printed, using a photoemulsion process, directly on canvas, stretched and primed by someone else and then captioned by a sign painter he had hired. Artists stepped away from the traditional processes of making art. They turned to new media that they labeled Conceptual, or Minimal, or Idea Art. Theirs was a critique of tradition, and a tough one.

Meanwhile, in Oregon, on May 18, just two weeks before his assassination, Bobby Kennedy had addressed crowds from the back platform of a campaign train dubbed the Beaver State Special, as it made its way down the Willamette Valley with stops in Oregon City, Salem, Albany, Harrisburg, and Junction City, culminating in a 2 p.m. address to a giant crowd at the University of Oregon's Hayward Field. He was back in the state a week later, on May 27, addressing a crowd at the Benton County Courthouse in Corvallis, the day before the Oregon primary against Senator Eugene McCarthy. Kennedy was defeated in Oregon, and McCarthy's anti-Vietnam War message carried the day.

In the wake of these events the students at both the UO and OSU sensed that they were caught up in a moment of transition. The faculty at the University of Oregon had been in place for decades, most notably, Andrew McDuffie Vincent, who had been appointed head of the art department in 1931 (a post he held until his retirement in 1968). Jack Wilkinson arrived in 1941 (and left to head the Louisiana State art department in 1968) and David McCosh in 1934 (retiring in 1970). Frank Okada would be hired at the UO in 1969, bringing new life to painting with his large-scale abstract paintings founded in a minimalist aesthetic. At Oregon State, Gordon Gilkey, who had learned printmaking under the tutelage of Maude Kerns at the UO in the 1930s, had assumed his role as head of the Art Department in 1947, hiring Nelson Sandgren, a student of McCosh's in Eugene, and shortly thereafter Paul Gunn and Demetrios Jameson. But in 1965, he hired Berkley Chappell, who had studied with Mark Rothko and was open to the new aesthetic possibilities of painting. In 1968, David Hardesty, a graphic designer from Cranbrook, schooled by Armin Hofmann in Zurich, and then in 1970, Clint Brown, a Pop sculptor/painter who brought a distinctive Pop sensibility from Southern California, joined the faculty. Nevertheless, until 1965 there had been no art major at OSU—and they have never been able to offer a graduate degree—even though, by 1970, there were seventeen full-time faculty in the department. Furthermore, if the OSU department was somewhat younger than the UO's, Corvallis was still, as it remained for many years, a far more conservative community than Eugene.

In fact, the faculty at both schools practiced what many of their students regarded as a rather tired modernism inspired chiefly by the landscapes of Cézanne, figurative Cubism, German Expressionism, and Surrealism. And if McCosh and Sandgren, particularly, approached the Oregon landscape in a way that continued to exert its influence on many of the painters in this exhibition—allowing the landscape "to think itself inside the painter," as Roger Saydack put it not long ago in an essay for an exhibition called *David McCosh*

and the Oregon School of Landscape Painting[19]—both Mc-Cosh and Sandgren would have understood the necessity of these younger painters to reinvent landscape in their own terms.

Still, other young painters, reading about new directions in *Artforum*, *Art in America*, and *ArtNews*, felt isolated in Eugene and Corvallis, where, nevertheless, by 1968, things were changing dramatically. A number of the younger artists in this exhibition who were undergraduates at the UO in the early 1970s remember Frank Okada's suggested reading list including Gregory Battcock's anthology *Minimal Art* for a non-studio course on painting concepts. There, they encountered Michael Fried's famous essay "Art and Objecthood" (reprinted from the June 1967 *Artforum*) in which he takes issue with Don Judd, Robert Morris, and Frank Stella for "giving up working on a single plane in favor of three dimensions" because that "automatically gets rid of the problem of illusionism and of literal space. … The several limits of painting are no longer present. … Actual space is intrinsically more powerful and specific than paint on a flat surface."[20] Or, as a number of artists in the exhibition have concluded, it might prove interesting to work between and among these dimensional possibilities. Or they might remember Paul Sarkisian's brief teaching stint in 1970, when he was working on full-scale monochromatic photo-realist paintings of ramshackle storefronts photographed on his journeys across the country and explore photorealism for themselves. Or they might remember another visiting instructor, Morris Yarowsky, who gave credit to one student for teaching him to play pool and urging students to throw away their tiny brushes and stop painting flowers. Yarowsky had a unique style of teaching painting. Famously, he would watch students paint and then politely stroll up and ask, "Could I paint on your painting?" Delighted, they said "Yes, of course," and loading a brush with black paint he would draw an X across the painting, saying, "Now start over!"

This is all to suggest that, even as things were changing, the artists in this exhibition found themselves at the very outset of that change, largely left to fend for themselves and cast out into an uncertain aesthetic world that was entirely in flux and open to—just about anything. The variety of their responses is evident in the rich variety of imagery that makes up this exhibition. But they all do have something in common. That

pivotal year, 1968, taught them that nothing was certain, that tradition and the status quo should be questioned, that there were many possibilities of which their mentors could not even dream. They understood that art was as much about thinking as seeing, that a painting was not so much an object as an idea—a complex idea, maybe not completely understood, but a place to begin. So, the careers of these artists can be defined as a process of continual exploration, beginning with an idea, thought, or glimpse, not necessarily fully processed and perhaps not fully understood. But in this process, in the act of painting, over the years—adding, subtracting, erasing, and changing—they discover in the paint itself a new life realized in the continual renewal and reinvention that constitutes each of these artists' distinctive "visual magic." The painters in this exhibition began their careers at a moment of enormous social, political, and aesthetic change, and their work has never shied from accepting change as the primary condition of their enterprise. Many have had distinguished careers as teachers in their own right and opened their sense of painting's inexhaustible possibilities to younger generations of Oregon painters. Their reach has sometimes been local, but just as often national and international, and it is revelatory to witness, in this exhibition, the scope of their talent and to recognize their centrality to the history of painting in the Northwest and beyond.

Endnotes

1 The transcript of this "Peer Dialogues" interview, completed during the artist's sabbatical from Portland Community College during the 1990-91 academic year, appears in "Exploring the unexplainable: Visual Rightness." Reprinted in: Robert Dozono, with introduction by Gina Carrington and commentary by Michael Knutson [and others], *Robert R. Dozono : Accumulation : Work 1963-2009* (Portland, Oregon: Blackfish Gallery, 2010), 226.

2 In 1949, McCosh took a sabbatical leave for one academic year to paint at Cohasset Beach, Washington; San Miguel de Allende, Mexico; and New Mexico. In 1958, he painted in England, France, Italy, Morocco, and Spain.

3 Email from George D. Green, November 11, 2018.

4 The importance of documenting this time and the artists it produced was especially evident in our early planning conversations with Green, Hise, Terry Melton (Director of the Oregon Arts Commission and Foundation, 1970-75; Regional Representative for the National Endowment for the Arts, 1975-84; and Executive Director of the Western States Arts Federation, 1984-90), Ken O'Connell (UO alumnus and professor emeritus, who helmed the Department of Fine and Applied Arts from 1984 to 2006); GDGAI board members Dan Biggs and Reagan Ramsey, and the late Hope Pressman.

5 This group of instructors included Givler's good friend Louis Bunce, Manuel Izquierdo, George Johanson, Frederic Littman, Hilda Morris, and Michele Russo. Roger Hull. "William Givler (1908-2000)," **Oregon Encyclopedia** entry, oregonencyclopedia.org/articles/givler_william_1908_2000_/#.W9tg7-JlCUk. Accessed November 1, 2018.

6 Email from George D. Green, September 6, 2018.

7 Gloria Mulvihill. "Richard Thompson, Artist." Interview from June 2015. portlandinterviewmagazine.com/interviews/art/richard-thompson-artist. Accessed October 31, 2018.

8 Bruce Guenther, "The Fountain Gallery, An Appreciation," in *The Fountain Gallery of Art – 25th Anniversary Edition* (Portland: The Fountain Gallery of Art, 1986), 11. Guenther was curator of contemporary art at the Seattle Art Museum at the time of this writing. He later served as chief curator and Robert and Mercedes Eichholz Curator of Modern and Contemporary Art at the Portland Art Museum from 2000 to 2014.

9 The exhibition *Two Oregon Painters – Craig Cheshire – Vernon Witham* was presented at the University of Oregon Museum of Art (now the Jordan Schnitzer Museum of Art) from June 23 through July 25, 1965.

10 Virginia Haseltine, "The Oregon Collector at Home," *Pacific Northwest Art: The Haseltine Collection [A catalogue compiled by the collector, Mrs. William A. Haseltine]* (Eugene, Oregon: University of Oregon Friends of the Museum of Art, 1963), 1-29.

11 Construction of the Oregon State Capitol's new wings was the impetus for the Percent for Art Program. Between 1976 and 1978, 170 works of art were purchased or commissioned for the Capitol; several of these were by *Visual Magic* artists. Meagan Atiyeh, "The Capitol Art Collection: Three Decades Later," in *Art of the Time: Oregon's State Capitol Art Collection* (Salem, Oregon: Oregon Arts Commission and Oregon State Capitol, 2011), 5.

12 Each sitter posed for approximately one hour for Johanson's "painting-drawing," essentially an oil paint sketch. The project was dedicated to Louis Bunce, who taught at the Museum Art School from 1946 to 1972. Johanson's *Studio with Bunce Mask,* on view in *Visual Magic,* also commemorates his influence. *Equivalents: Portraits of 80 Oregon Artists* (published in conjunction with the exhibition of the same name, on view January 12 through March 24, 2002) (Portland, OR: Portland Art Museum, 2001), 10

13 Artist statement provided to Danielle Knapp, September 24, 2018.

14 Artist statement provided to Danielle Knapp, September 21, 2018.

15 Patti Smith, *Just Kids* (New York: HarperCollins, 2010), 69.

16 Robert Smithson, "A Sedimentation of the Mind: Earth Projects," *Artforum*, 7(September 1968), 440.

17 Octavio Paz, *Marcel Duchamp or The Castle of Purity*, trans. Donald Gardner (London: Cape Golliard Press, 1970), n.p.

18 Bernice Rose, "Sol LeWitt and Drawing," in *Sol LeWitt* (New York: Museum of Modern Art, 1978), 26.

19 Roger Saydack, "David McCosh and the Oregon School of Landscape Painting," essay for the exhibition of the same name, Karin Clarke Gallery, Eugene, OR, April 30–May 31, 2014.

20 Michael Fried, "Art and Objecthood," *Minimal Art: A Critical Anthology*, ed. Gregory Battcock (1968; rpt. Berkeley, CA: University of California Press, 2014), 84.

Colorplates

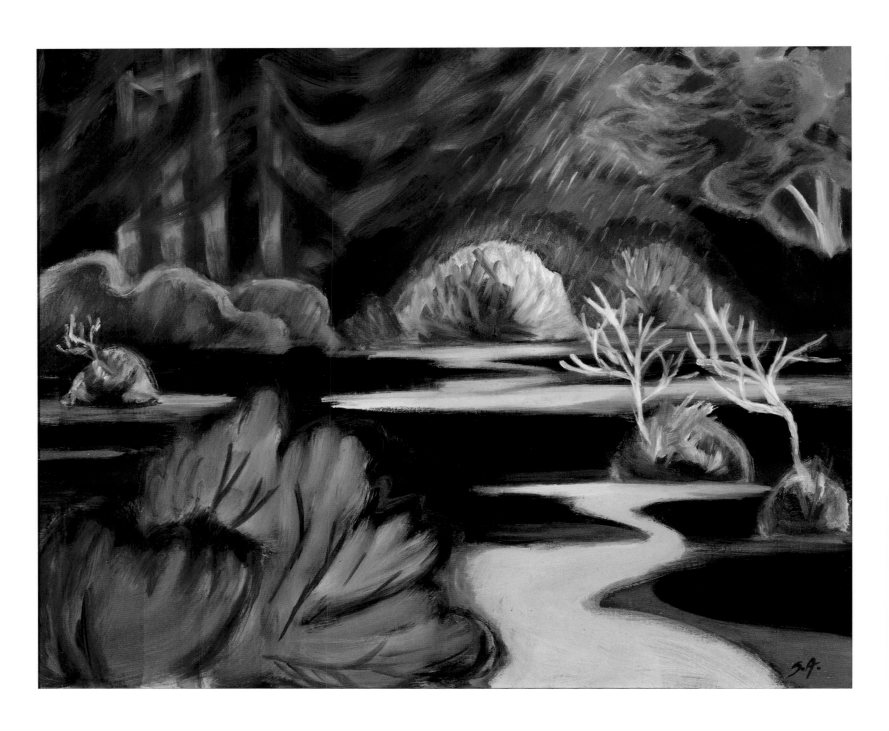

Susan Applegate. **Rain Shower Arc**, 2016. Oil on board, 17 ½ x 25 ½ inches. Courtesy of the artist.

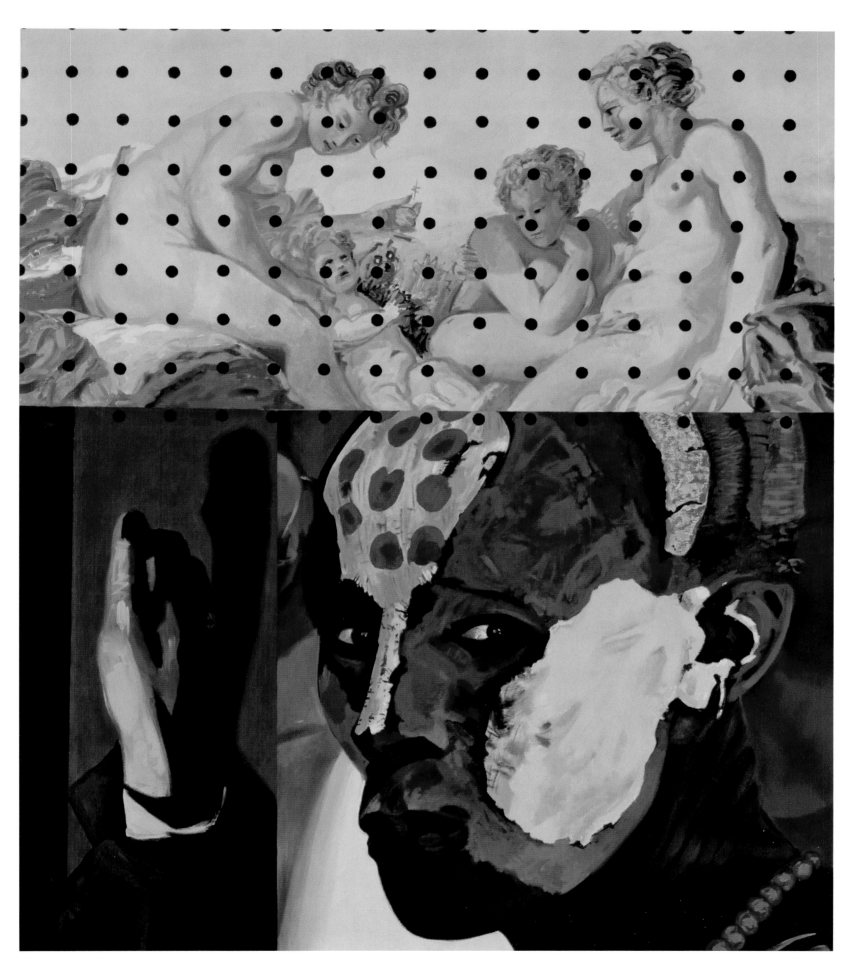

Jay Backstrand. **Split Screen**, 2010. Oil on canvas, 38 ½ x 33 inches. Courtesy of the artist and Russo Lee Gallery.

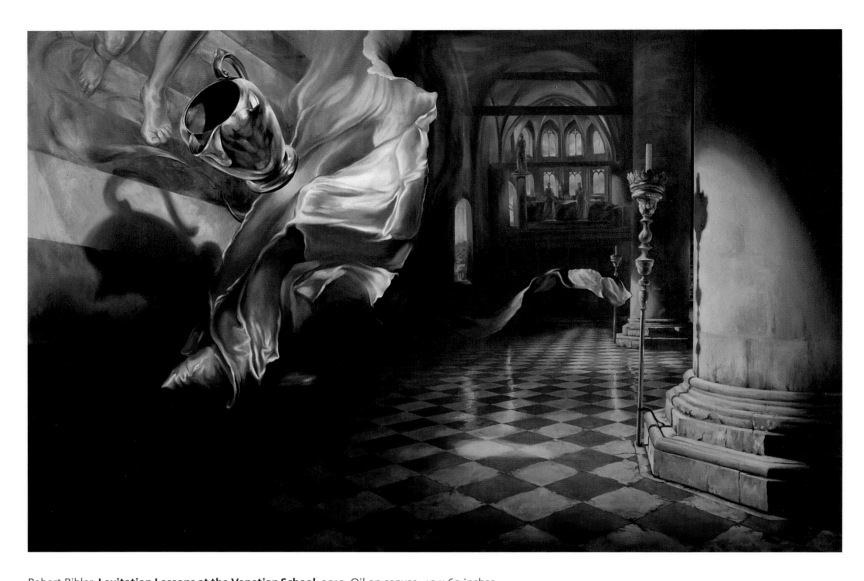

Robert Bibler. **Levitation Lessons at the Venetian School**, 2010. Oil on canvas, 40 x 60 inches.
Collection of the Jordan Schnitzer Museum of Art. The Bill Rhoades Collection, A Gift in Memory of Murna and Vay Rhoades.

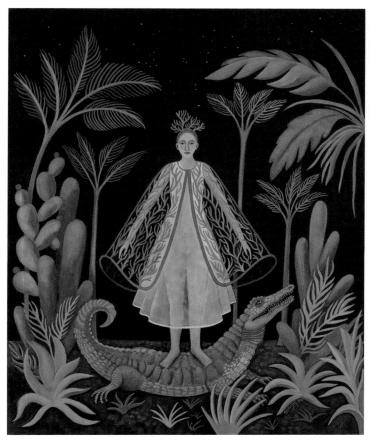
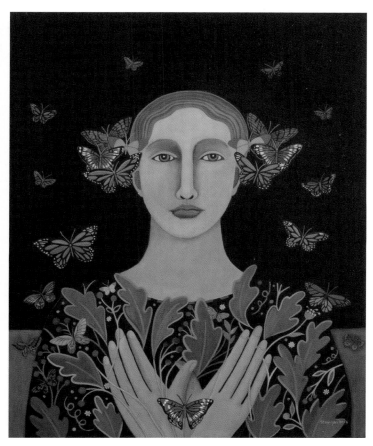
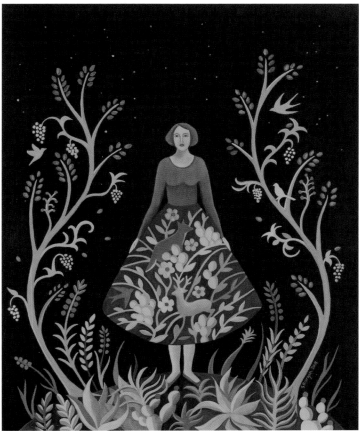
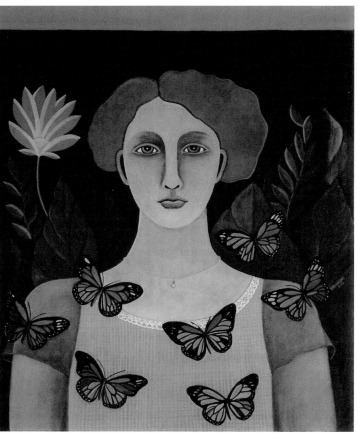

Clockwise:

Sharon Bronzan. **Body Guard**, 2018. Gouache on panel, 20 x 16 inches. Courtesy of the artist and Augen Gallery.

Sharon Bronzan. **Butterfly Effect**, 2016. Gouache on panel, 20 x 16 inches. Courtesy of the artist and Augen Gallery.

Sharon Bronzan. **Visitor**, 2017. Gouache on panel, 20 x 16 inches. Courtesy of the artist and Augen Gallery.

Sharon Bronzan. **Shaman's Skirt**, 2018. Gouache on panel, 20 x 16 inches. Courtesy of the artist and Augen Gallery.

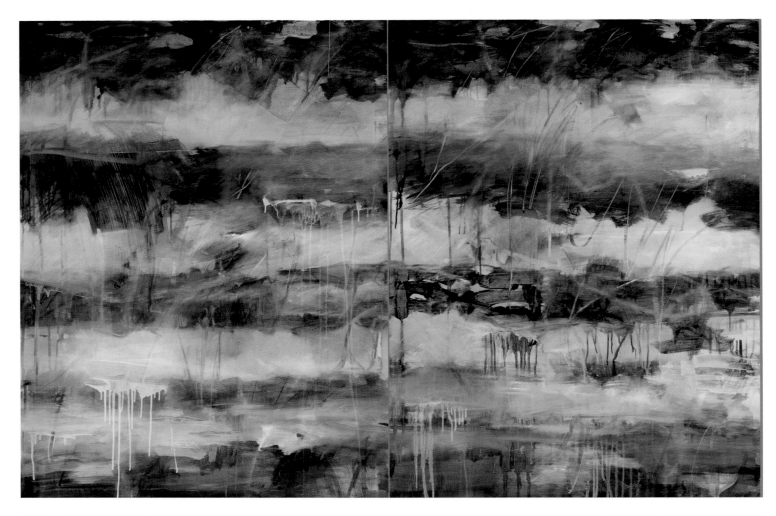

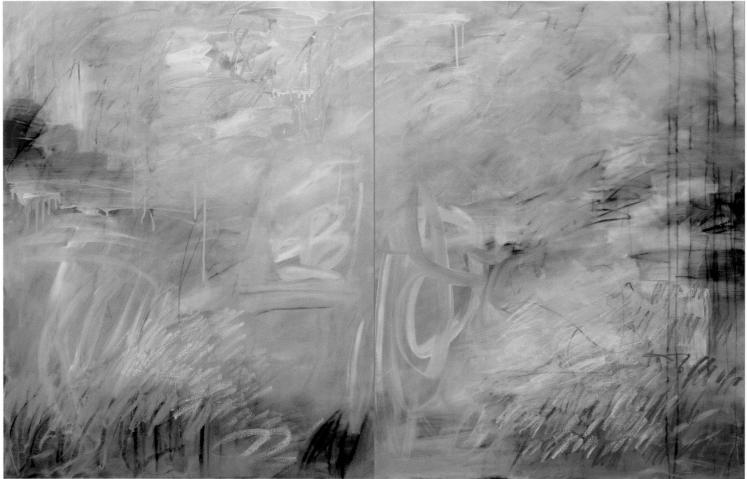

Sandy Brooke. **Alaska Arctic**, 2018. Oil and graphite on linen, 40 x 60 inches. Courtesy of the artist.

Sandy Brooke. **Fish at the Door**, 2017. Oil, graphite, and oil stick on linen, 40 x 60 inches. Courtesy of the artist.

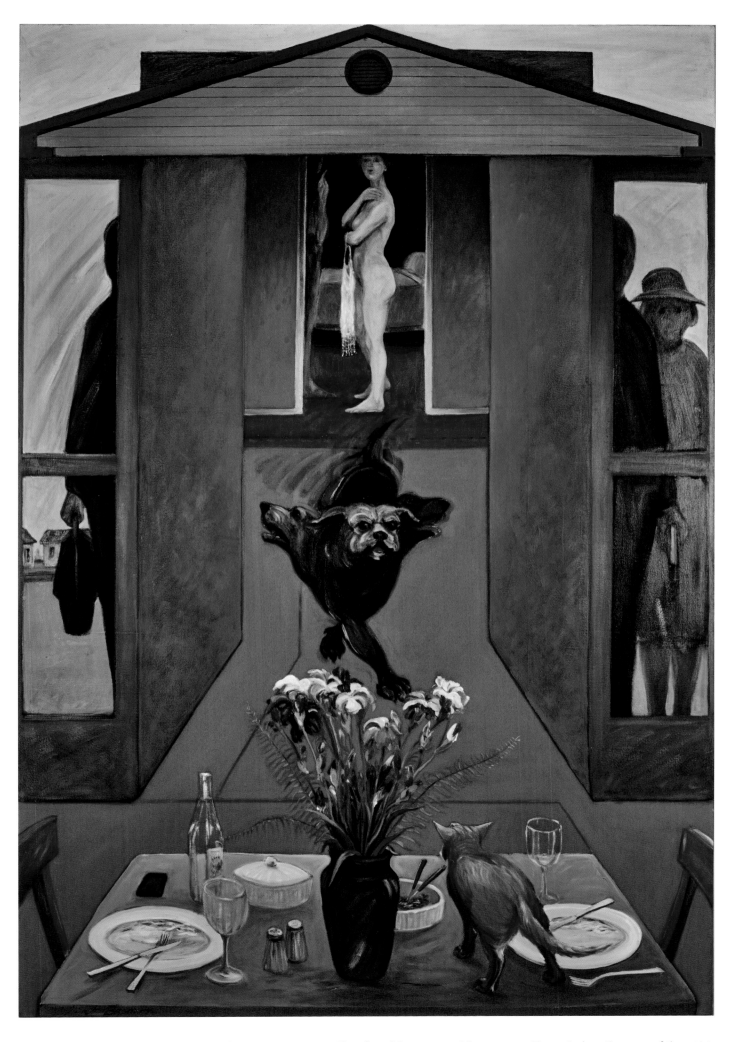

Clint Brown, **Between Church and State**, 2013. Oil on canvas, 68 x 47 inches. Courtesy of the artist.

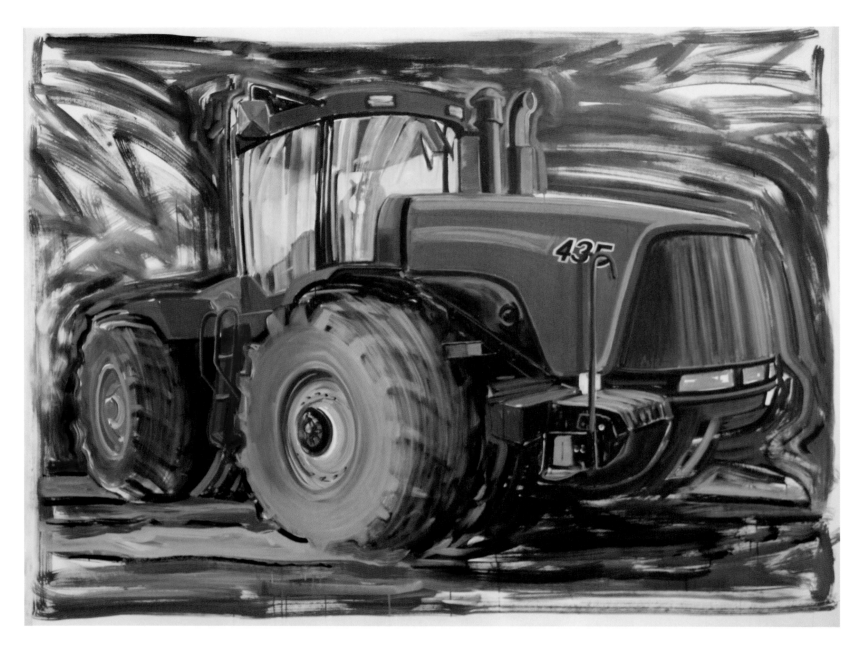

Karen Carson. **Big Red**, 2016. Acrylic on unstretched canvas with wax finish. 80 x 96 inches. Courtesy of the artist.

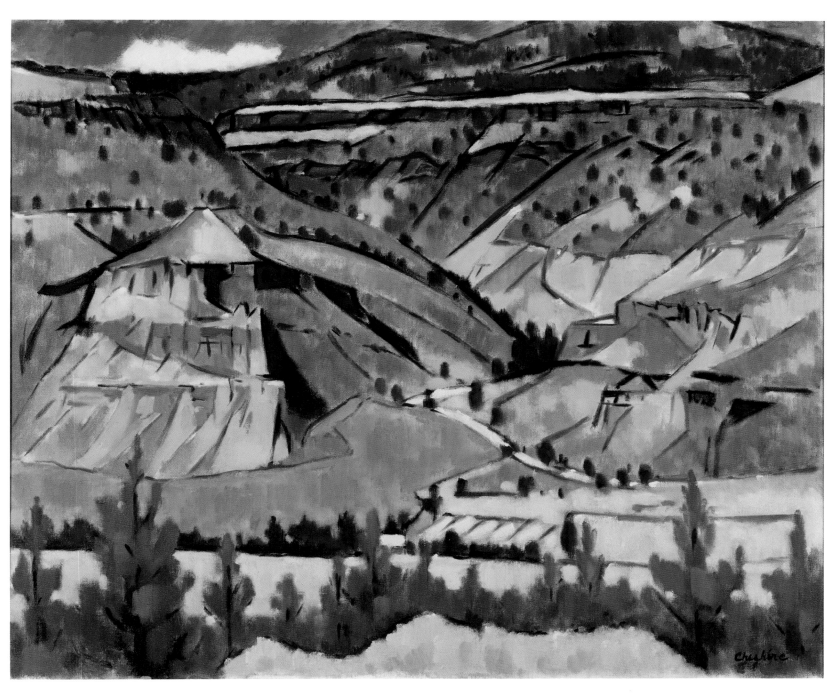

Craig Cheshire. **John Day Country**, 2010. Oil on linen, 36 x 42 inches. Courtesy of the artist.

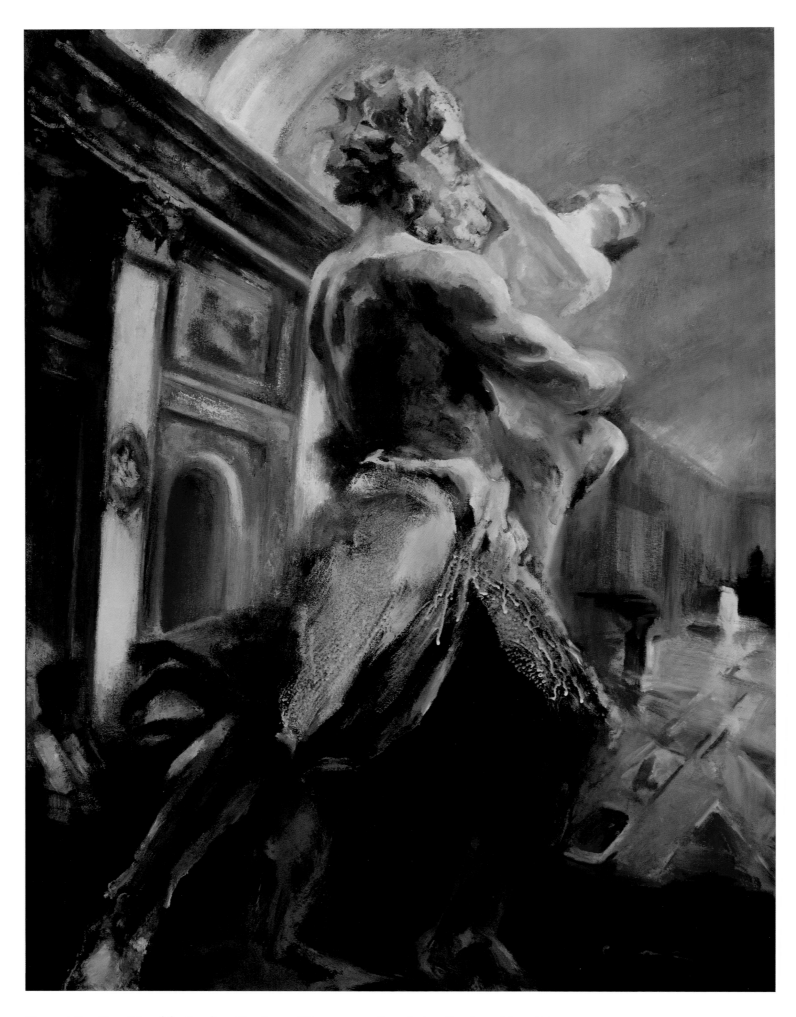

Margaret Coe. **True Crime (The Borghese Case)**, 2017. Oil on canvas, 48 x 37 inches. Courtesy of the artist.

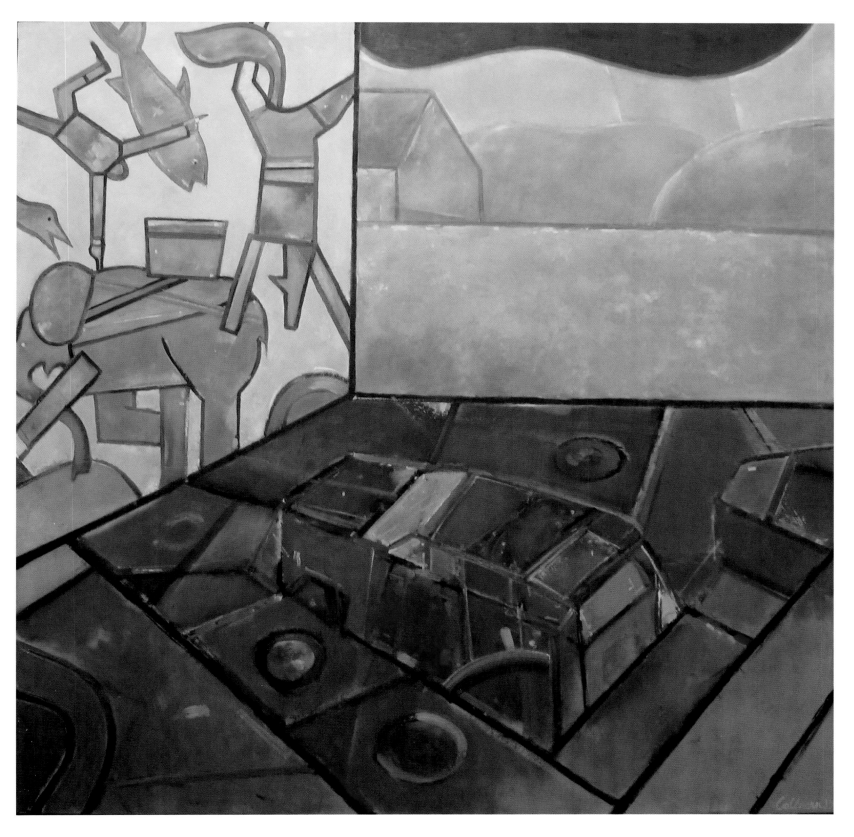

Jon Colburn. **Drive-In Drama**, 2017. Oil on aluminum, 49 x 49 inches. Courtesy of the artist.

 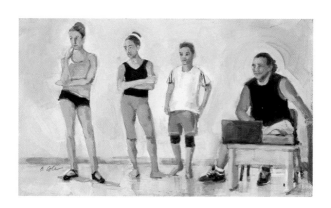

Bets Cole. **Vignettes (California, Canada, Cuba, Mexico, Oregon)**, 2018. Gouache on Canson Board, sizes vary (5 x 4 inches, 7 x 5 inches, 7 x 6 inches). Courtesy of the artist.

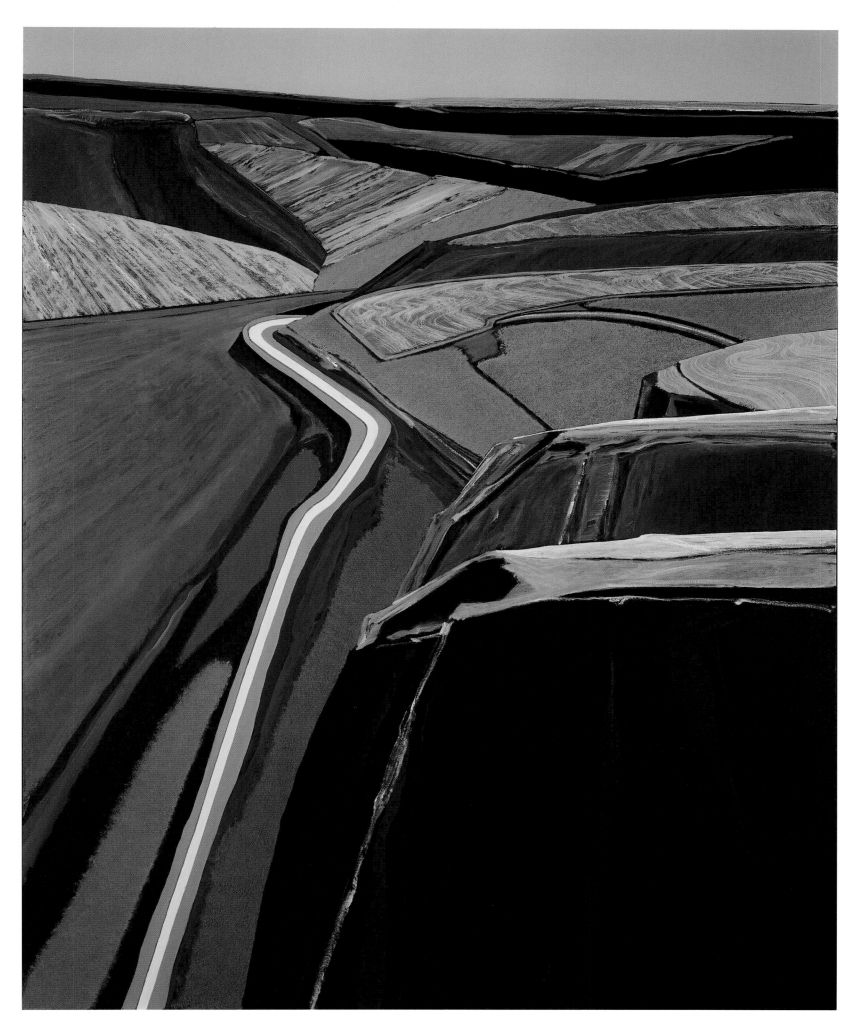

Jon Jay Cruson. **On the Edge**, 2017. Acrylic on canvas, 62 x 50 inches. Courtesy of the artist.

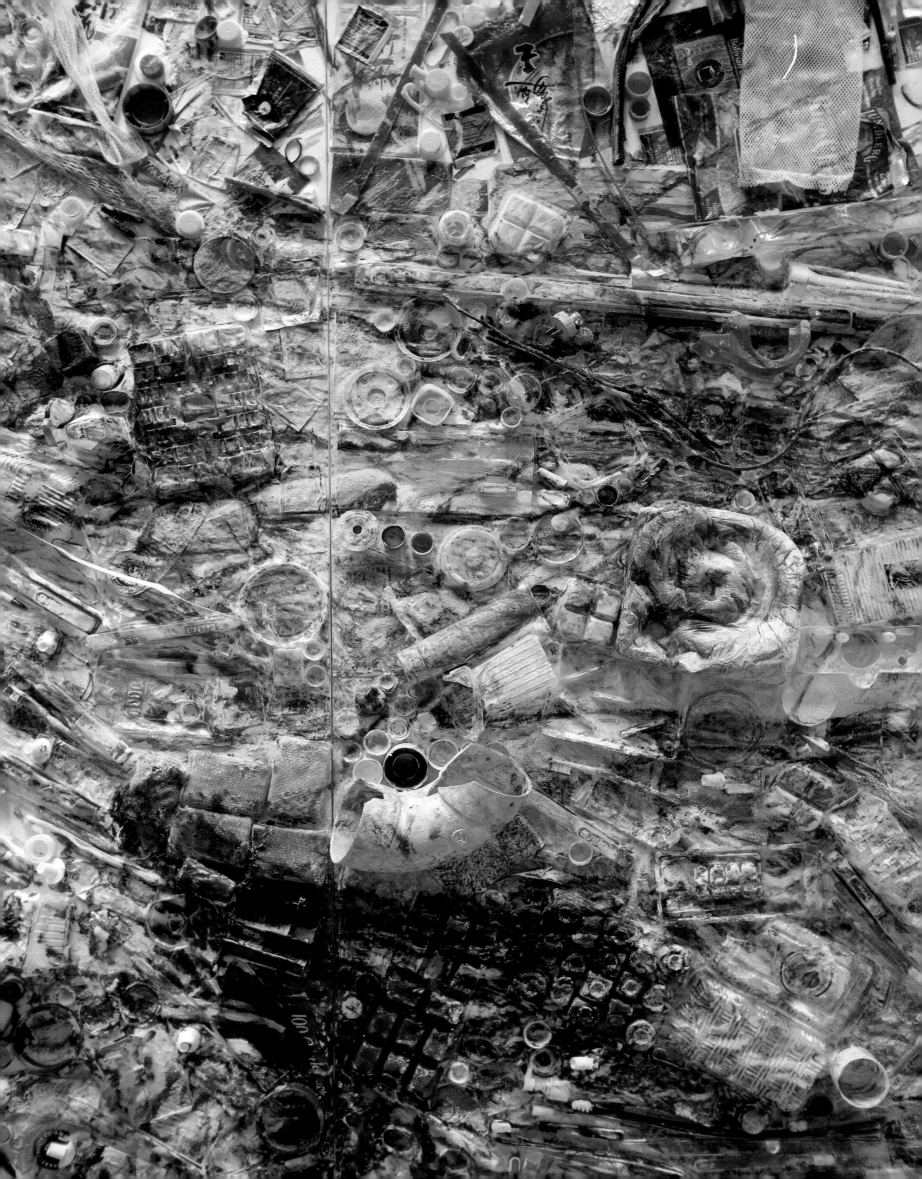

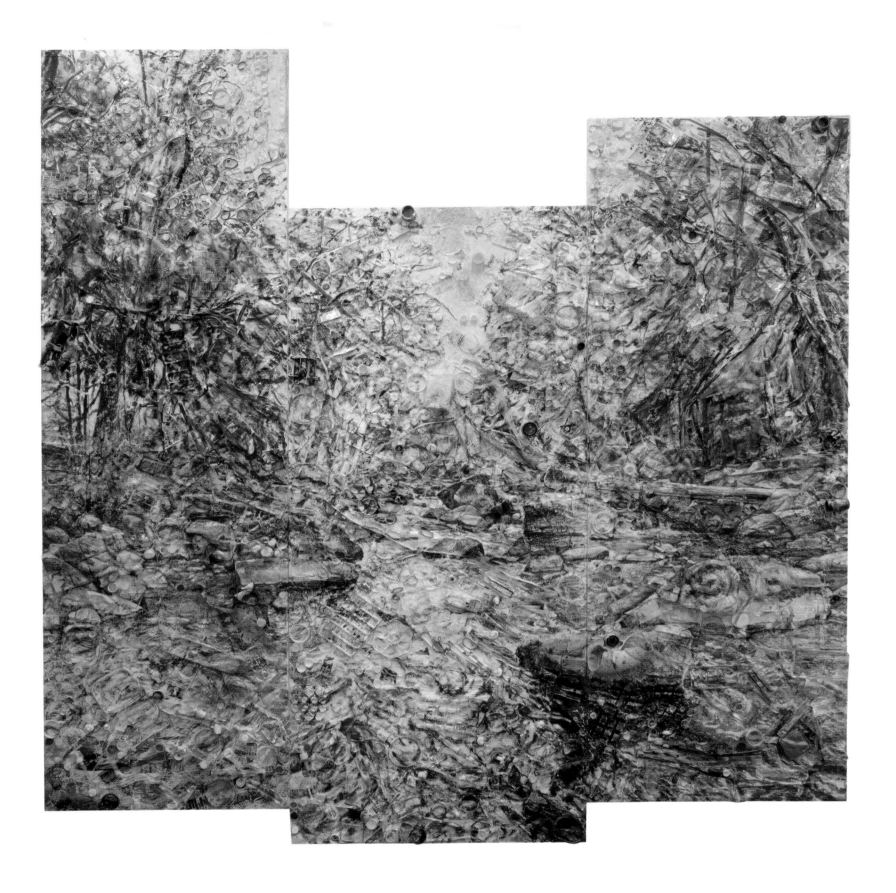

Robert Dozono. **No Farm—No Food—Take Back America, Upper Clackamas #11**, 2009. Oil, garbage on canvas, 135 x 131 x 6 ½ inches. Courtesy of the artist and Blackfish Gallery.

Left: Detail

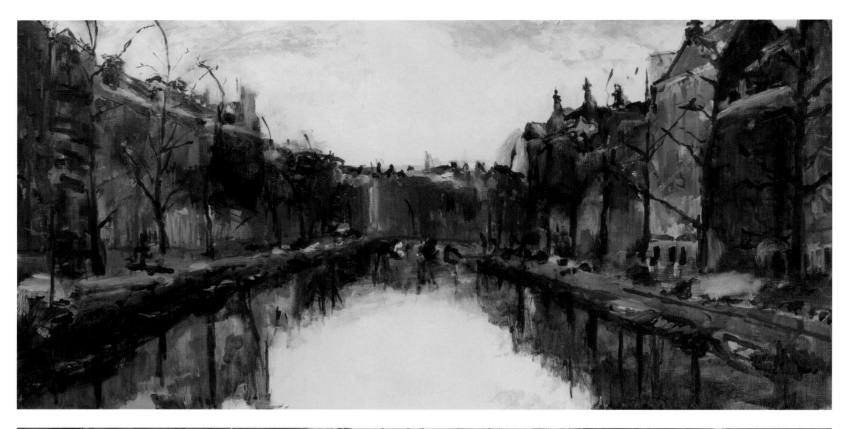

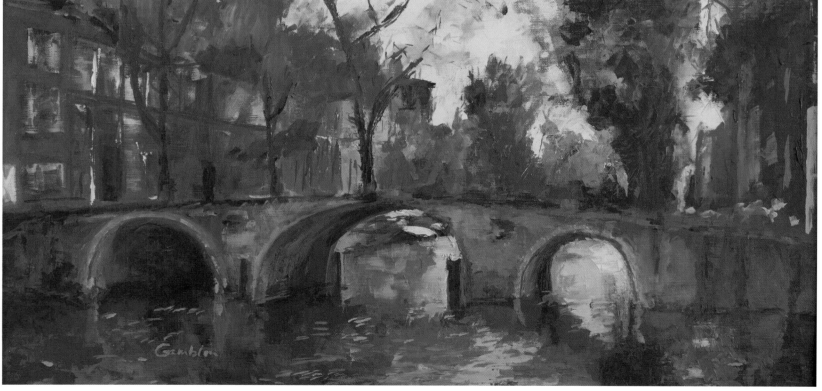

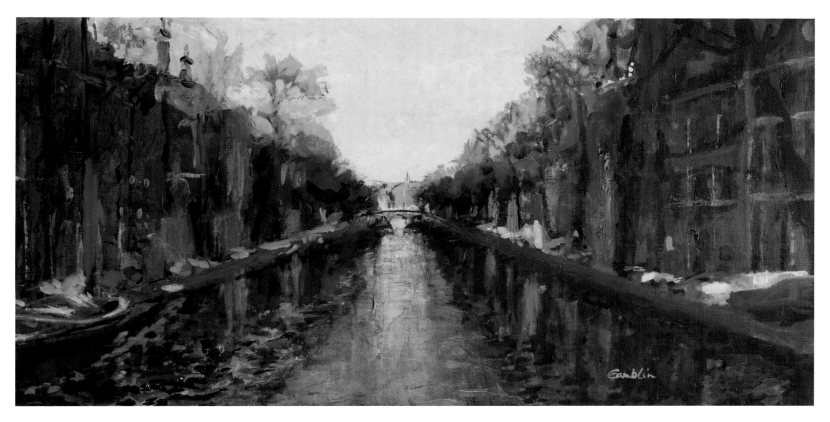

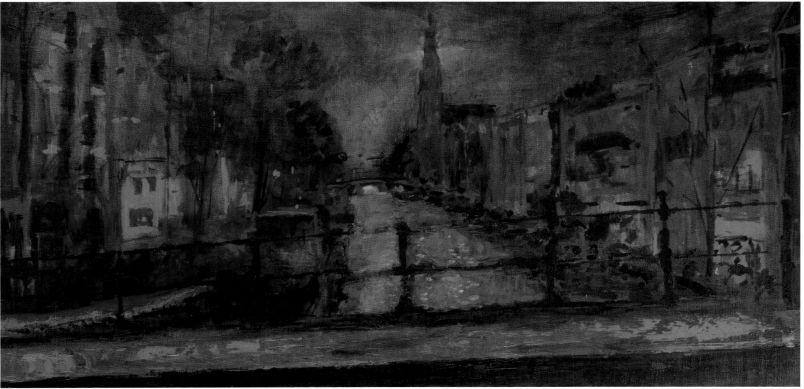

Robert Gamblin. Clockwise: **Amsterdam in Brown, Amsterdam in Prussian Blue, Amsterdam in Vermillion, Amsterdam in Delft Blue**, 2013
Oil and linen on panel, 17 x 33 inches (each). Courtesy of the artist.

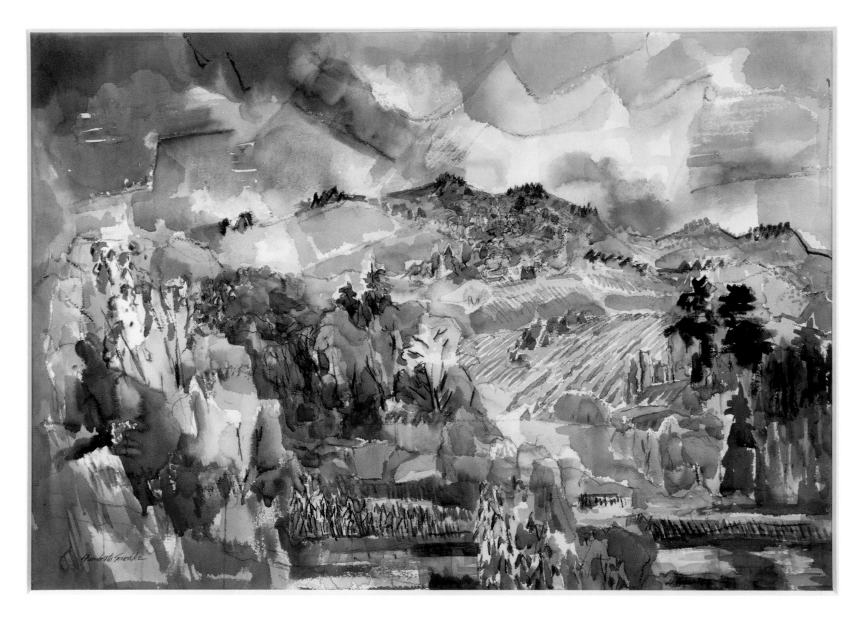

Humberto Gonzalez. **Oregon Autumn,** 2010. Watercolor on paper, 30 x 37 inches. Courtesy of the artist.

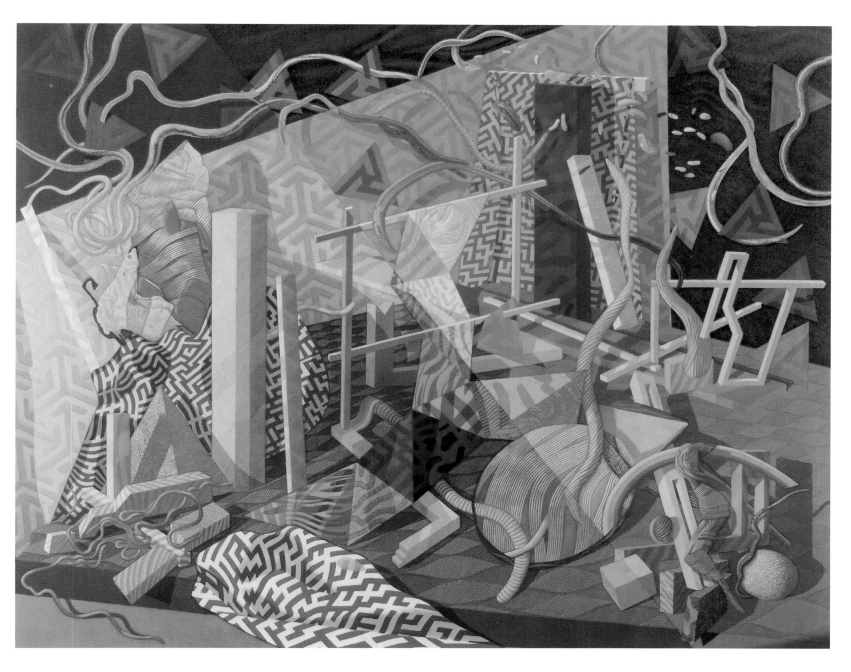

Dennis Gould. **200901**, 2009. Oil on panel, 48 x 60 inches. Courtesy of the artist.

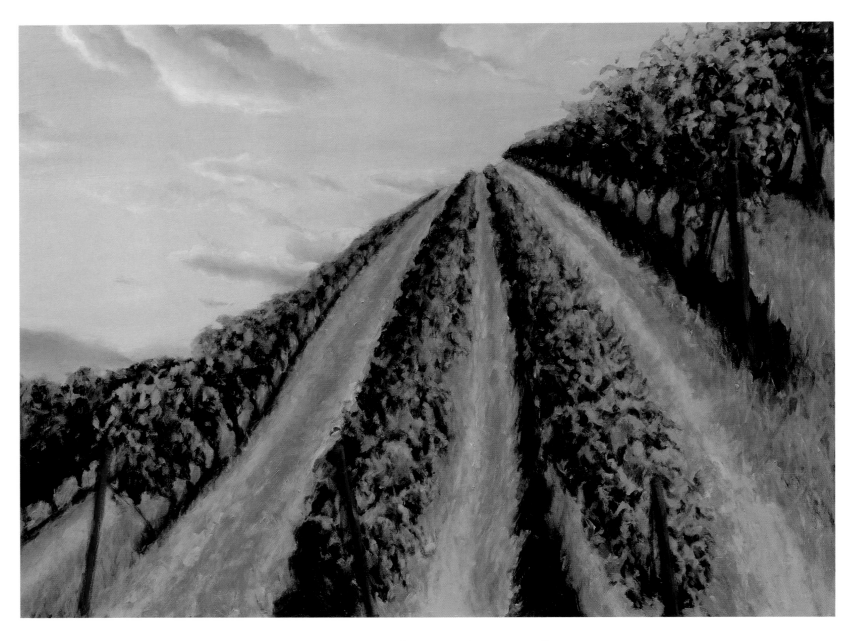

Cie Goulet. **Upper Vineyards**, 2016. Oil on wood, 34 x 44 inches. Courtesy of the artist and Russo Lee Gallery.

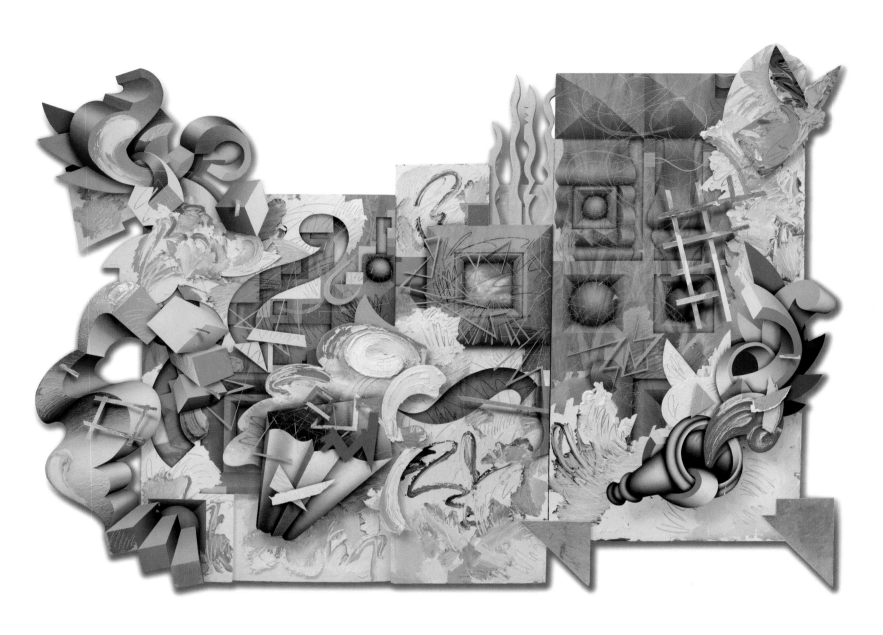

George D. Green. **Instantaneous everything**, 2018. Acrylic on panels, 109 x 126 inches. Courtesy of the artist.

George D. Green. **The Science of the Angels: Part 1 – La Creation du monde**, 2016. Acrylic on panel, 24 x 80 inches. Courtesy of the artist.

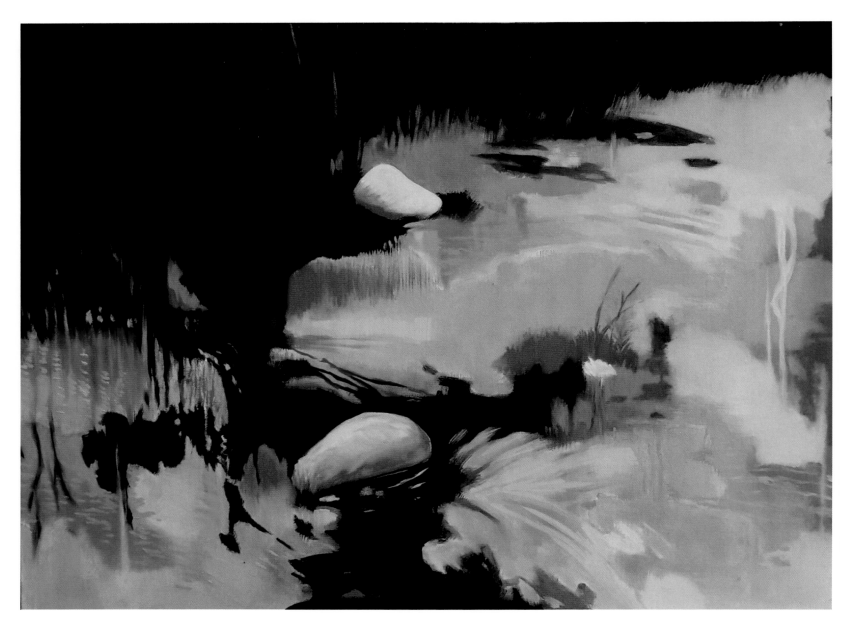

John Haugse. **Botanical Garden**, 2018. Oil on canvas, 20 x 30 inches. Courtesy of the artist.

Carol Hausser. **Traversing the Interior**, 2015. Watercolor on paper, 46 x 48 inches.
Collection of the Jordan Schnitzer Museum of Art. Gift of Carol Hausser and The Bill Rhoades Collection.

Jeri Hise. **The Transformation of Culture: Rembrandt's Children II**, 2015. Acrylic on canvas and wood panel, 71 x 71 inches. Courtesy of the artist.

Jeri Hise. **Vermeer Series: Mei Mei's Cyclops**, 2016. Acrylic on canvas, 58 x 70. Courtesy of the artist.

George Johanson. **Studio with Bunce Mask**, 2016. Acrylic and oil on canvas, 42 x 62 inches. Courtesy of the artist and Augen Gallery.

Leland John. **Rocky Creek, Oregon Coast**, 2018. Oil on linen, 32 x 42 inches. Courtesy of the artist.

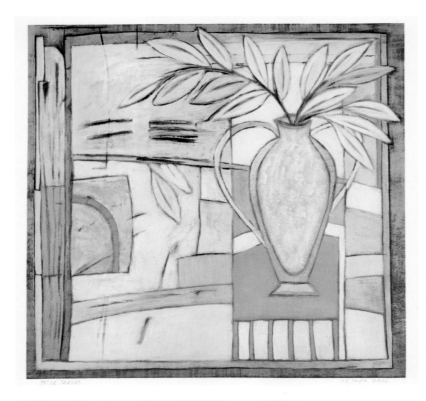
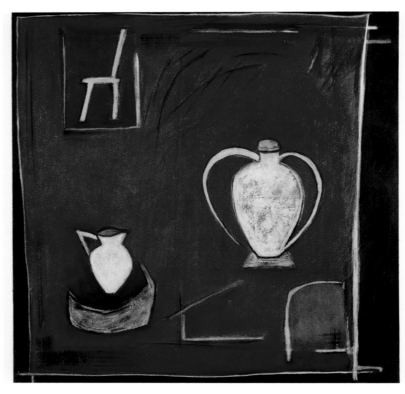
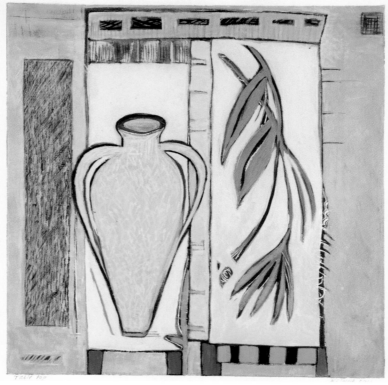

Clockwise:
Kacey Joyce. **Blue Leaves**, 2016. Acrylic on rag paper, 10 x 10 inches. Courtesy of the artist.

Kacey Joyce. **Solitude**, 2018. Acrylic on rag paper, 10 x 10 inches. Courtesy of the artist.

Kacey Joyce. **Yellow Room**, 2018. Acrylic on rag paper, 10 x 10 inches. Courtesy of the artist.

Kacey Joyce. **Table Top**, 2016. Acrylic on rag paper, 10 x 10 inches. Courtesy of the artist.

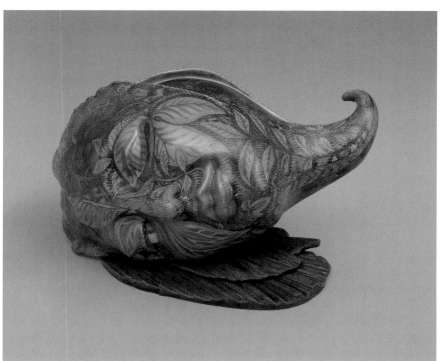

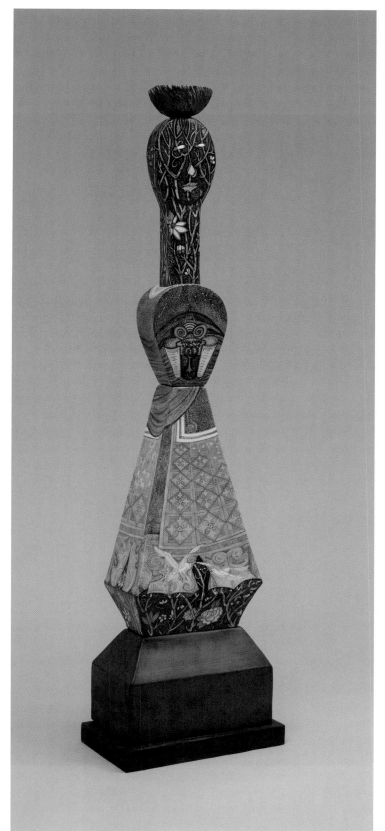

Left: Connie Kiener. **Golden**, 2018. Maiolica ceramic, 7 x 10 ½ x 10 ½ inches. Courtesy of the artist and Russo Lee Gallery.

Right: Connie Kiener. **Earth and Sky**, 2018. Maiolica ceramic, 51 x 11 x 7 inches. Courtesy of the artist and Russo Lee Gallery.

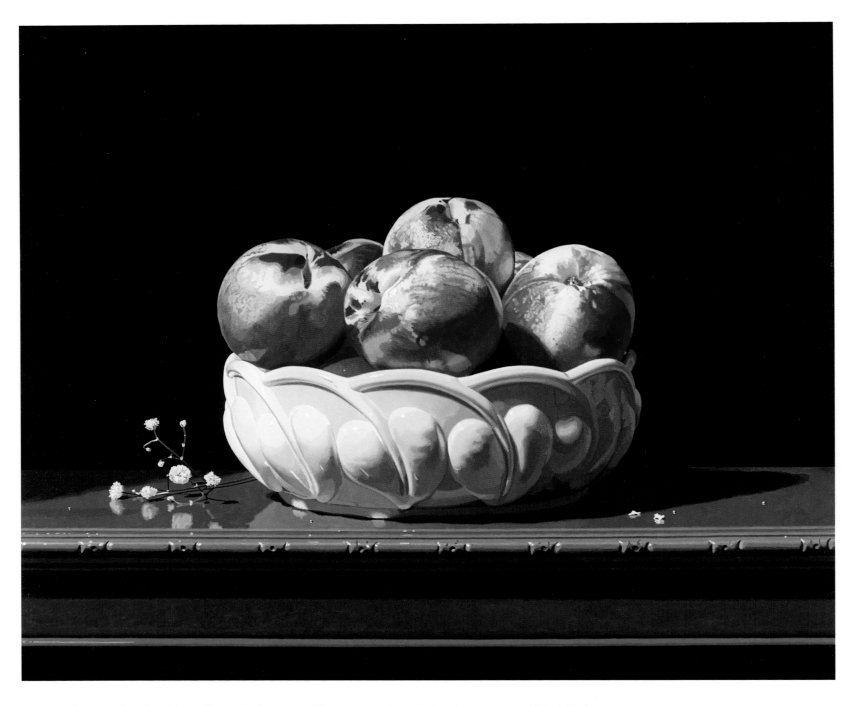

Edwin Koch. **Nectarines in White Tulip Bowl**, after 2010. Oil on canvas, 36 x 30 inches. Loan courtesy of Seth Koch.

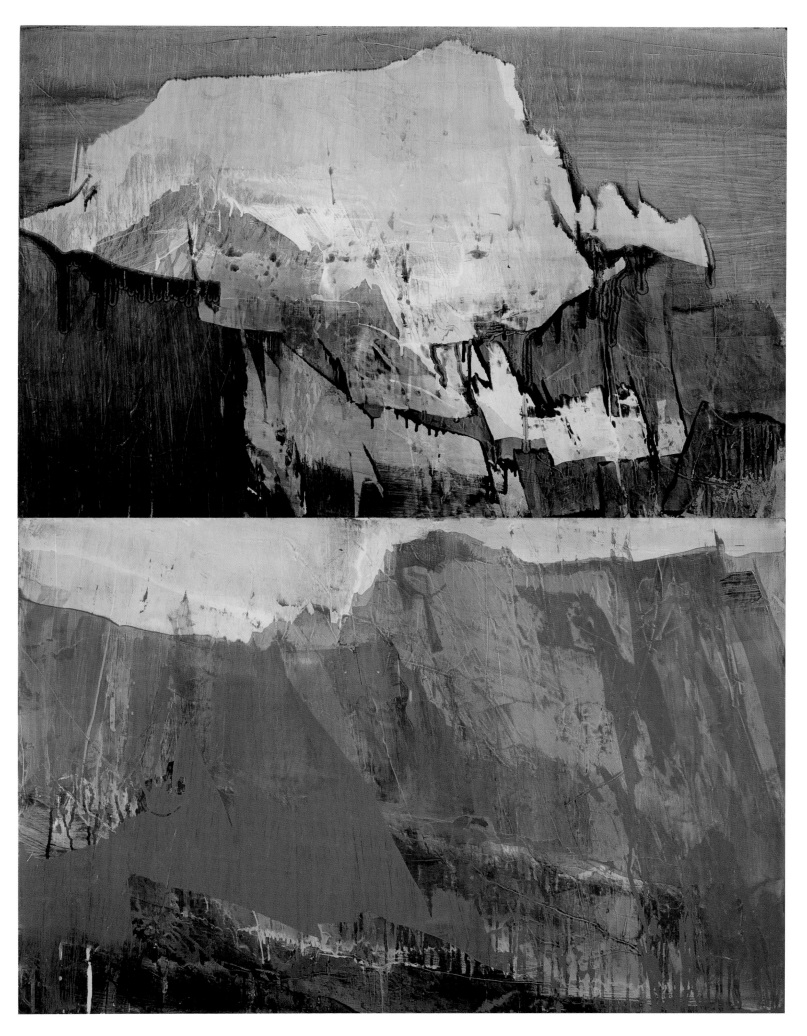

James Lavadour. **Contact**, 2016. Oil on panel, 64 x 48 inches. Courtesy of the artist and PDX CONTEMPORARY ART.

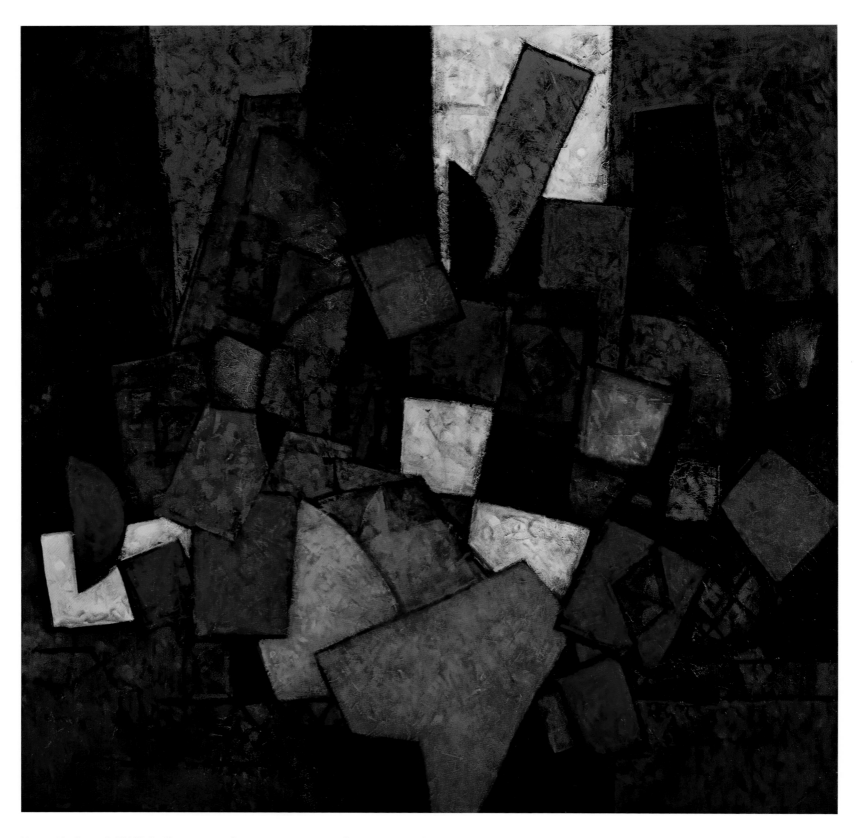

Nancy Lindburg. **Still Life in Flux**, 2014. Oil on canvas, 30 x 30 inches. Courtesy of the artist.

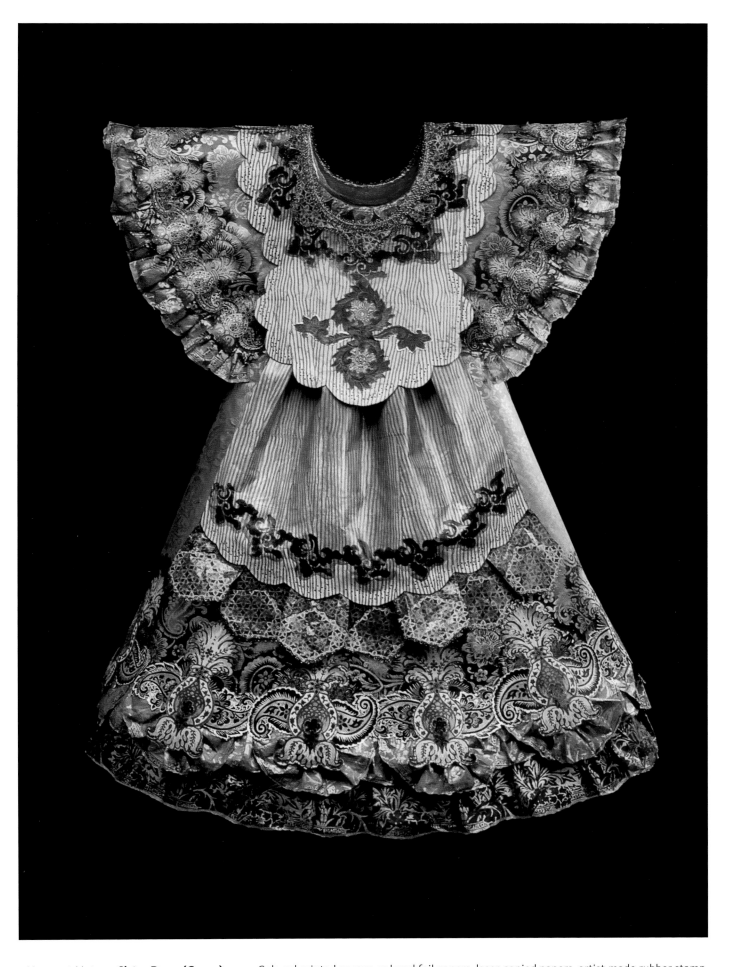

Margaret Matson. **Sister Dress (Green)**, 2010. Colored printed papers, colored foil papers, laser-copied papers, artist-made rubber stamp, glue, inks, basswood, copper, cast iron; hand cut, printed, painted, glazed, carved, hammered, tacked, 48 x 22 1/16 x 18 7/8 inches. Courtesy of the artist.

Sue-Del McCulloch. **Spring in Clover-Time**, 2015. Acrylic on canvas with wax finish, 48 x 60 inches. Loan courtesy of Lisa Ford.

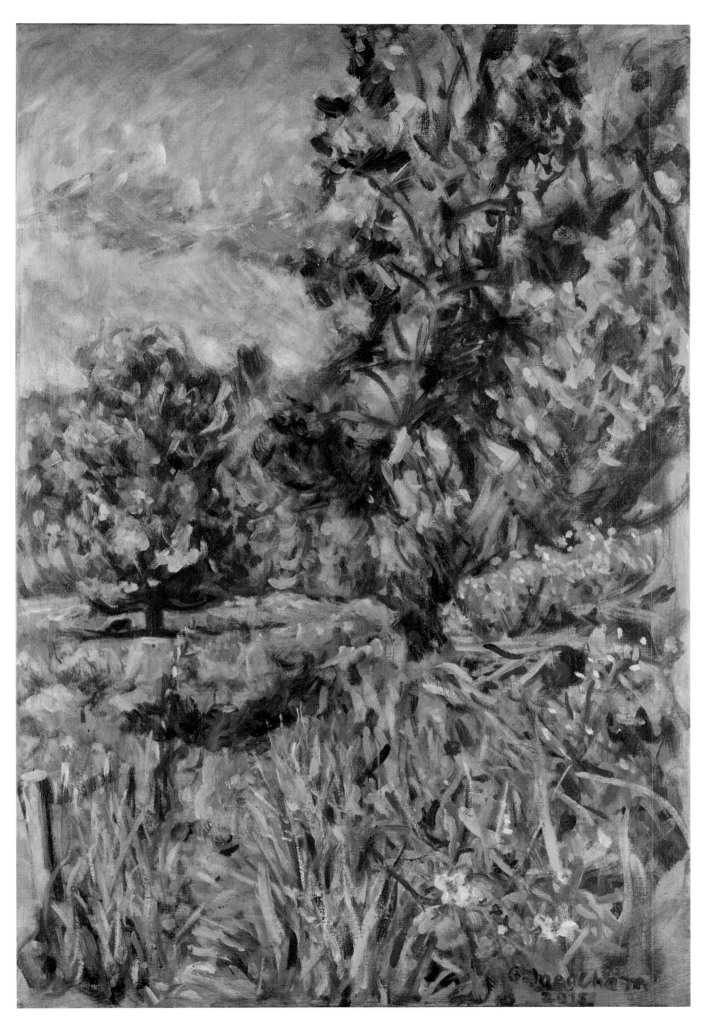

Gary Meacham. **Sauvie Island Scene**, 2015. Oil on canvas, 38 x 26 inches. Courtesy of the artist.

Terry Melton. **Flatland**, 2017. Acrylic on canvas, 40 x 48 inches. Courtesy of the artist.

Terry Melton. **Starbelt**, 2017. Acrylic on canvas, 48 x 40 inches. Courtesy of the artist.

Selection of sketchbooks by
Ken O'Connell. 2006-2018.
Pen and ink, watercolor, and
colored marker, sizes vary.
Courtesy of the artist.

August 3, 2010
La Romita School of Art
Ken O'Connell

IL FORNO
SPOLETO
tel. 40307

label on the paper
bag.

Spoleto was another hill town that presents unique problems for the person with limited walking ability. Orvieto and Assisi were the others. Two and I found that all three had mini-buses as well as limited foot access to the main stops, if one was careful to plan and use them to help see as well as enter some of these sights, sites!

This sketch above used very limited tools, pencil, 03 sepia Multiliner that came as its last leg with a damaged tail, a yellow BS 30 multiliner, a blue copic sketch marker and a toothbrush that some violent brown ink in a tiny flicks and and a pastel I note that I used to loosen color a bit above the page to limit the sprayed color of the airbrush to the side and similar area of the base of the image.

"Pastry sketch demo for Mary after visit to SPOLETO"

ORVIETO 9/12/19
ONION AUTO
Ken O'Connell

BOMARZO GARDEN
10-16-2016

started 8/18/18 water color sketches
8/19/18

STRONCONE 2 SEPT 2006 Ken O'Connell

20 FEB 2010
Wiesbaden,
Germany

Peter Holtz started selling Copic markers in 1987. His Salers Europe heard from style those popular markers in november 1.

Peter Holtz was an exceptional Host for Marianne, Debbie, and I during our 7 day stay in Wiesbaden, Germany. He helped us to experience the best of food and music, and view of the city and villages nearby. We also spent the better part of a day in the Gutenburg museum in Mainz, across the river from Wiesbaden. The Rhine...

A primary purpose of our trip was to teach Certification classes to papermarker store Owners and designers who demonstrate copic markers and how to use them in performing art stores and workshops. We also met chigen/Horitston, a professor and talented graphic illustrator expert. He published my work calc?t Visualizing ideas, he was to teach a workshop in the SOPH ACADEMY for Papermarkers and Illustrators. Horan I. Arnold sees no her envolvement with this charge in place was a treat to go out to the whole country and drive through beautiful villages and have a wonderful land. An aspect a day one of the hills her sketching the Rhine valley. He released a do-part music concert and learned a set intent. We desire a fantastic of visit again. Also, they had a workshop set for the musician that I must visit- Peter suggested that I may want to develop/prepare such a sketchbook/workshop in this area in the coming years. I think, that, also the real possibility in planning and developing such a trip?

Homburg Papermill 16-23 FEB 2010
Hattenheim FRANKFURT
Holigarten WIESBADEN
Rudesgheim MAINZ
 ALONG THE RHINE RIVER

Mit meinem Bücker geht die Sonne auf!

Apple turnover from bakery near hotel Stolberg, in Germany to conduct certification for Copic marker.

Visit to Studio of TAKEUCHI in Tamayen/gu OYAMAZAKI 2020
3-19-14
He started with Shino but there are now many... Daisha after dong Crace Ikm explore Oribe style his pieces? to so to reliable work Iam pottery and verify Zegeced his Studio to os so reliable work, his and his wife Shizenoten Come from dry having out ORI in Vacomont site... nother at the college in Karoson and ted visiting there got 35 marks in Kyoto and sonic-ham with Takguchi. Then kerokord and could meet us in JORI and drive us to TAKEUCHI home.

MR. TAKEUCHI was very friendly and accommodating for our visit... allowed to mangfi his sketches and list of his pottery in working with jay in college Shizenoten beautifully

NARA DEER PARK

FIVE-STORY PAGODA

• Near his 5-story Pagoda was the NARA NATIONAL MUSEUM full and I mean full of Buddha, orange statues of Buddha as well as other painted Bodhisattva— no pictures to be taken as sketching allowed only view and be moved by the power of this life force of the Buddha. The head of Buddha sometimes had a smaller head growing out in the hairline of the forehead and sides I WOULD.

No Shino style

Kenzan style

Vietnam pot he bought there in antique shop.

his chose style.

Paula Overbay. **Dissipation II**, 2017. Acrylic on paper, 11 x 16 inches. Courtesy of the artist.

Paula Overbay. **Gyration**, 2017. Acrylic on wood, 22 x 28 inches. Courtesy of the artist.

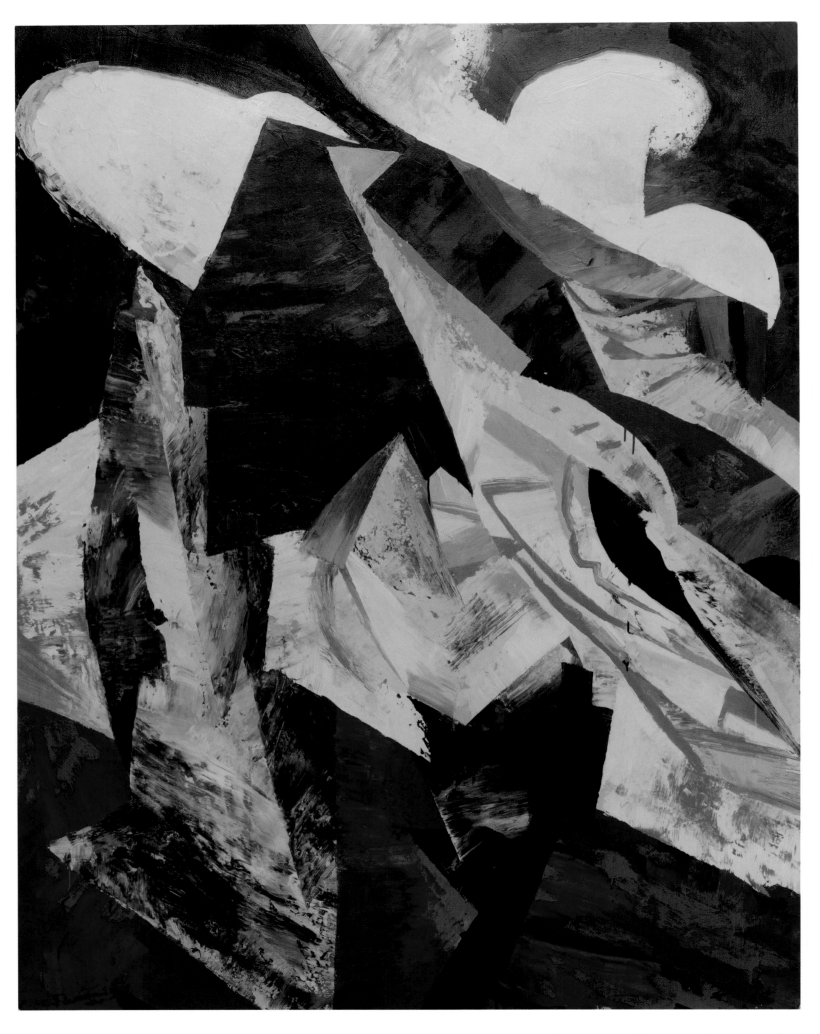

Lucinda Parker. **Retreating Ice**, 2015. Acrylic on canvas, 78 x 60 inches. Courtesy of the artist and Russo Lee Gallery.

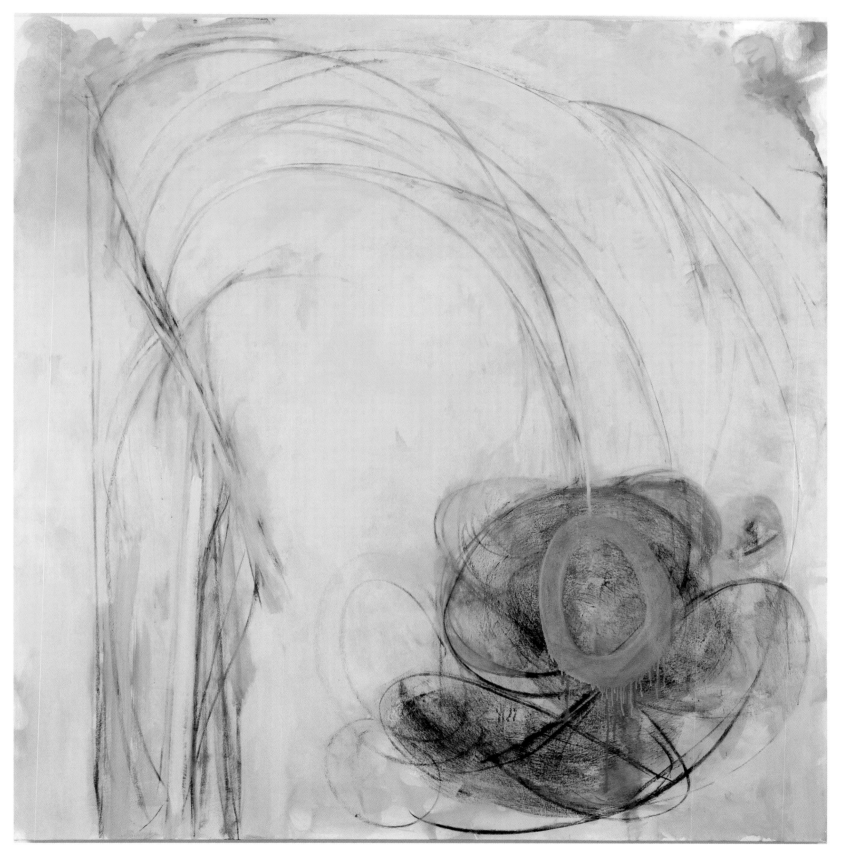

Jan Reaves. **Lapsed Pruning**, 2016. Oil and acrylic on canvas, 71 ¾ x 67 ½ inches. Courtesy of the artist's family and Russo Lee Gallery.

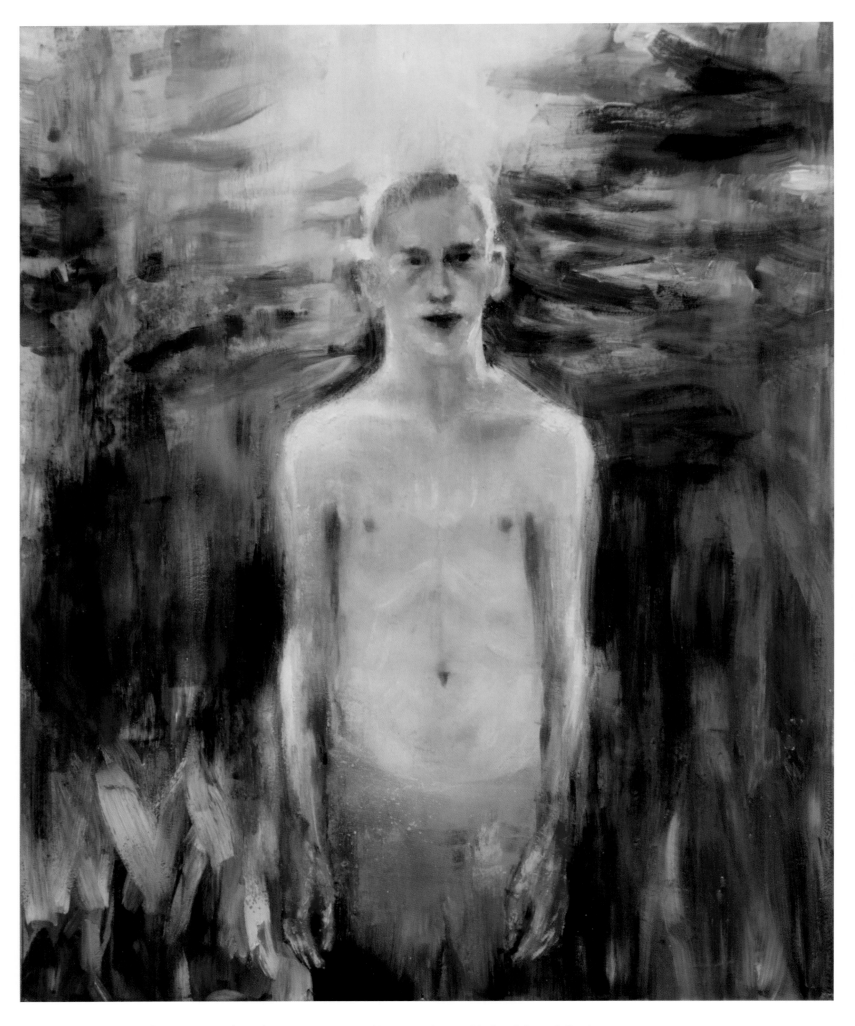

Laura Ross-Paul. **Hot Hands**, 2017. Watercolor/Oil/Wax/Resin on Terraskin on Board, 20 x 16 inches. Private Collection.

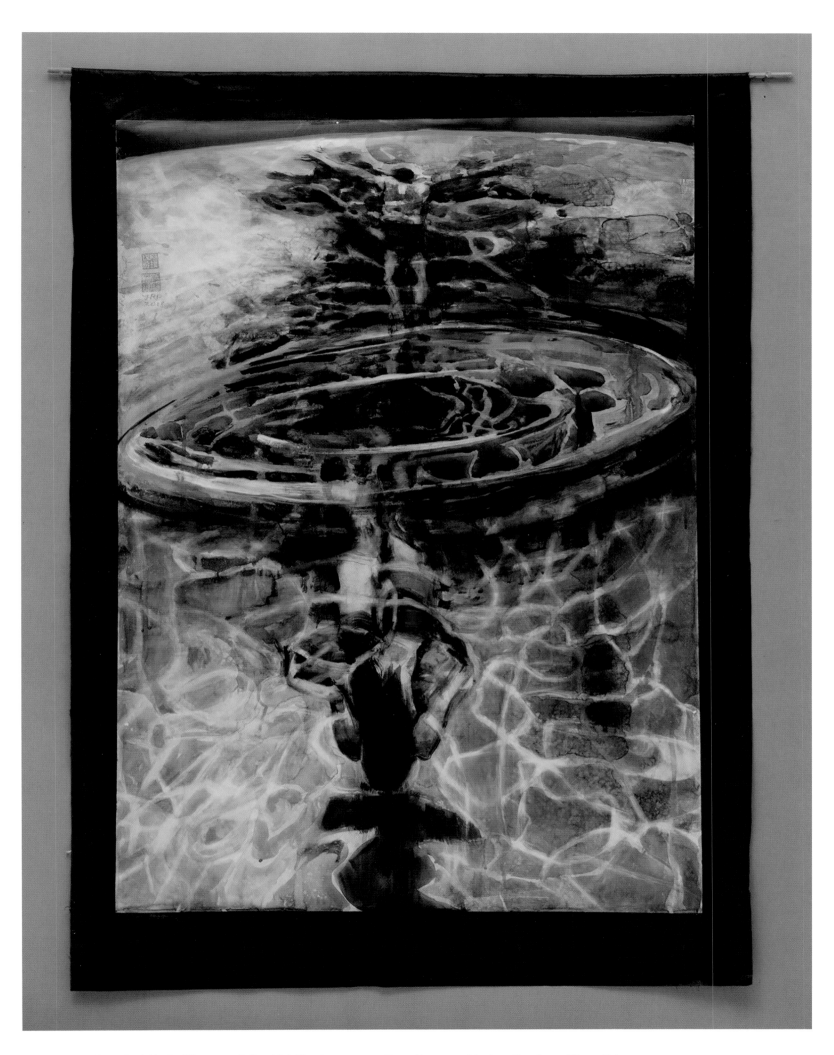

Laura Ross-Paul. **Under Water**, 2018. Sumi Ink/Pearl-essence on Terraskin, 40 x 28 inches. Courtesy of the artist.

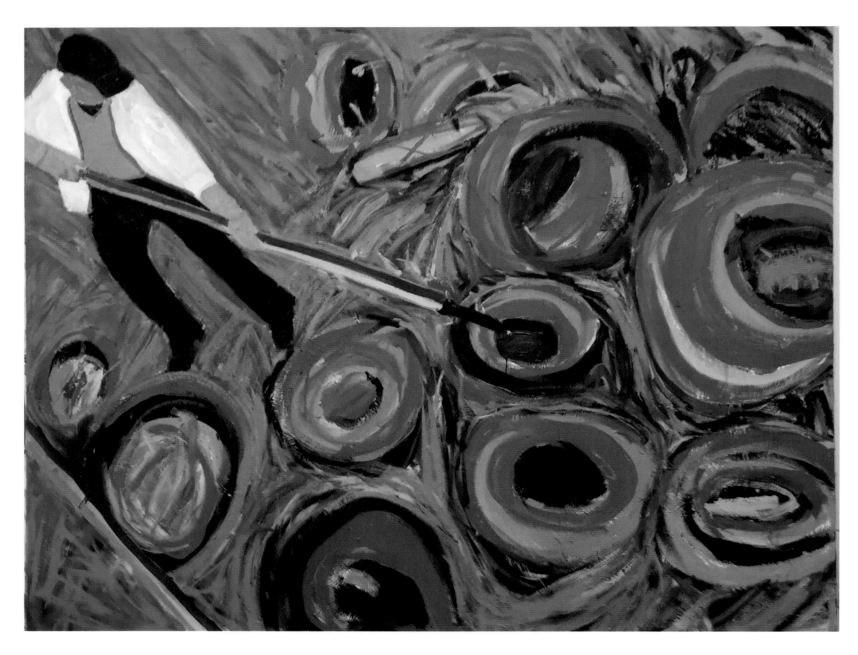

Sandra Roumagoux. **Spring Run**, 2016. Oil on canvas, 48 x 60 inches. Courtesy of the artist.

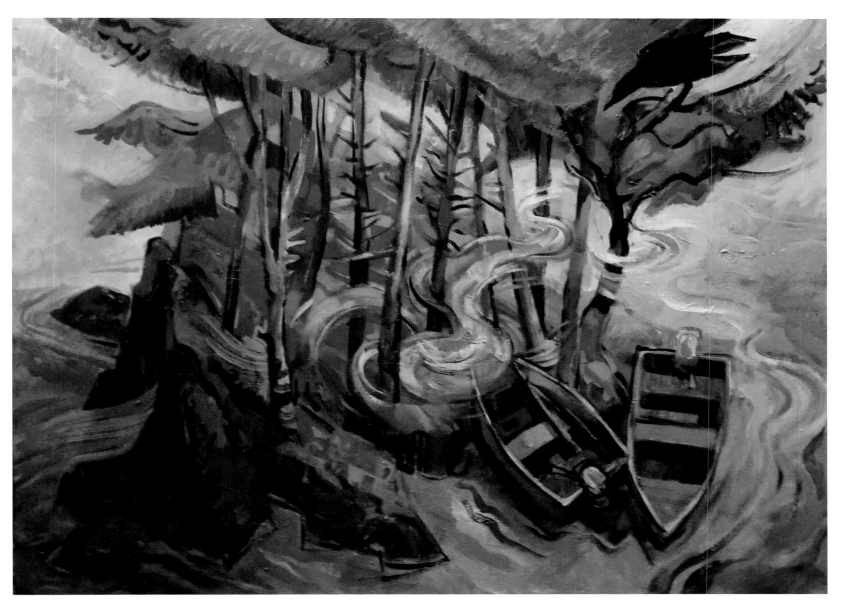

Erik Sandgren. **Island Visitor**, 2014-18. Acrylic on canvas, 40 x 54 inches. Courtesy of the artist.

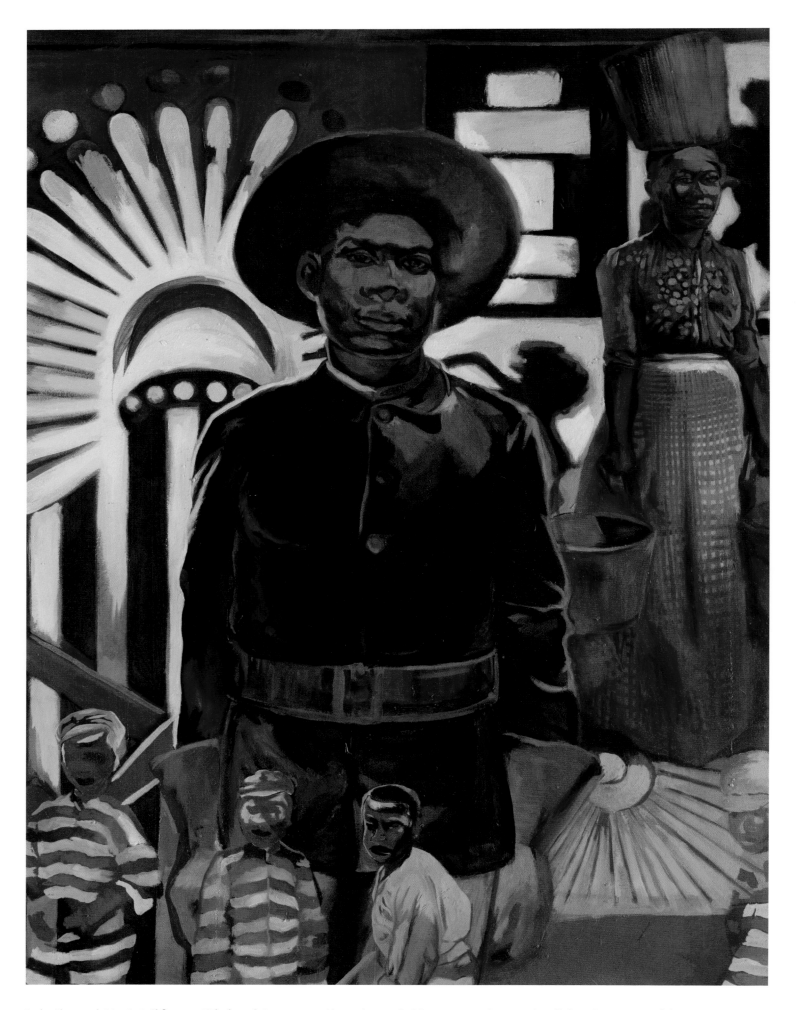

Isaka Shamsud-Din. **Detail from untitled work in progress**, November 2018. Oil on canvas, 58 x 54 inches (full size). Courtesy of the artist.

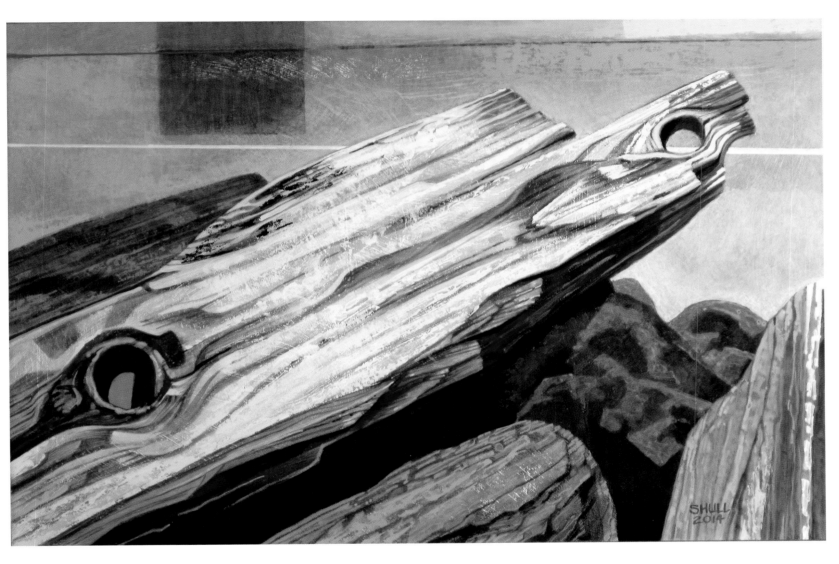

Jim Shull. **Relics 10**, 2014. Acrylic on canvas, 17 x 25 inches. Courtesy of the artist.

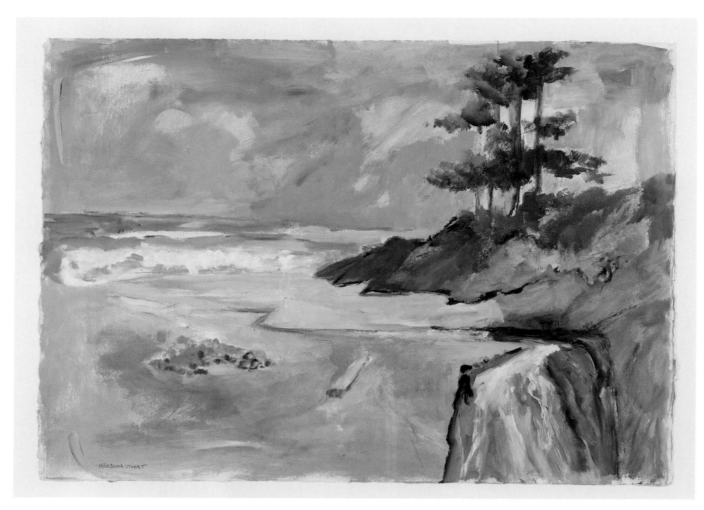

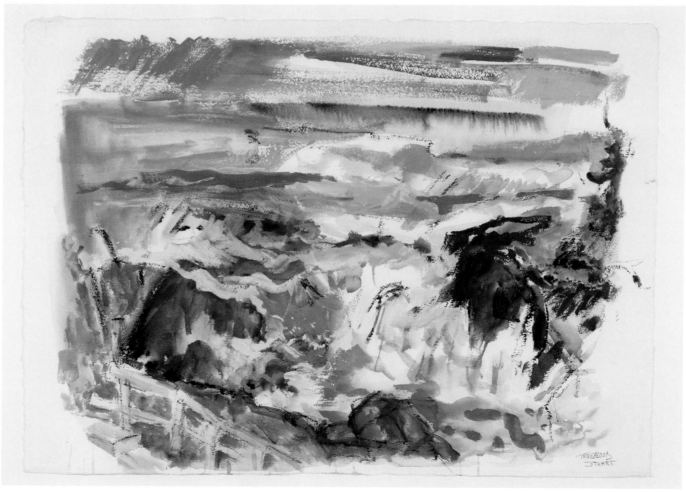

Susan Trueblood Stuart. **Creek to the Sea**, 2018. Acrylic on paper, 30 x 38 inches. Courtesy of the artist.

Susan Trueblood Stuart. **Summer at Devil's Churn**, 2014. Acrylic on paper, 30 x 38 inches. Courtesy of the artist.

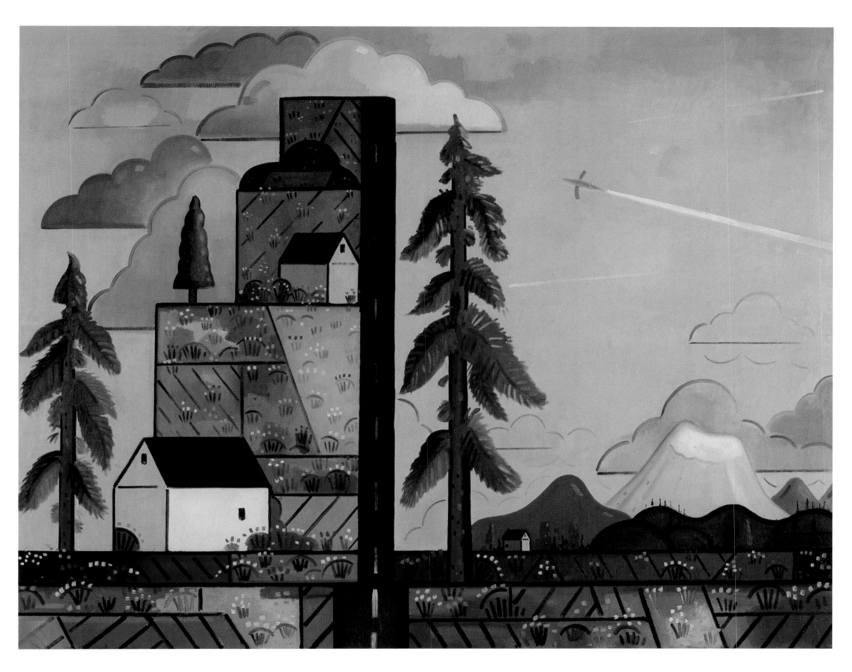

Richard Thompson. **Road and Range**, 2017. Oil on canvas, 52 x 66 inches. Courtesy of the artist.

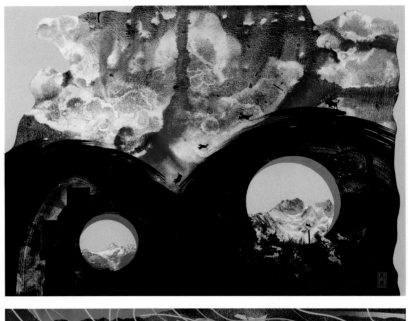

Clockwise:
Bullying Bovine Behaves Belligerently, 2018. Made by Hugh H. Webb fully aware of herd dynamics.
Acrylic and mixed media, 28 x 36 inches. Courtesy of the artist.

Mister Moose Manages Misadventure, 2018. Made by Hugh H. Webb while thinking how relatively infrequently this happens.
Acrylic and mixed media, 28 x 36 inches. Courtesy of the artist.

P-40 Purposely Propels Patriotically, 2018. Made by Hugh H. Webb thinking about the wild blue yonder.
Acrylic and mixed media, 28 x 36 inches. Courtesy of the artist.

Migrating Mcguffins Maintaining Mindfullness Maneuvering Maelstrom, 2018. Made by Hugh H. Webb wishing he possessed such sangfroid.
Acrylic and mixed media, 28 x 36 inches. Courtesy of the artist.

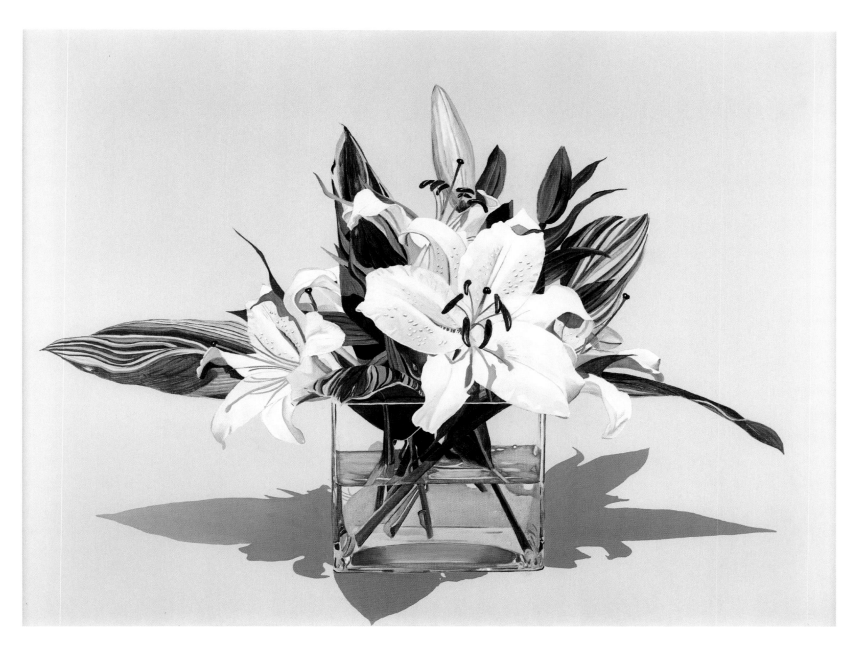

Phyllis Yes. **Calm Lillies**, 2017. Acrylic on canvas, 36 ½ x 48 ½ inches.

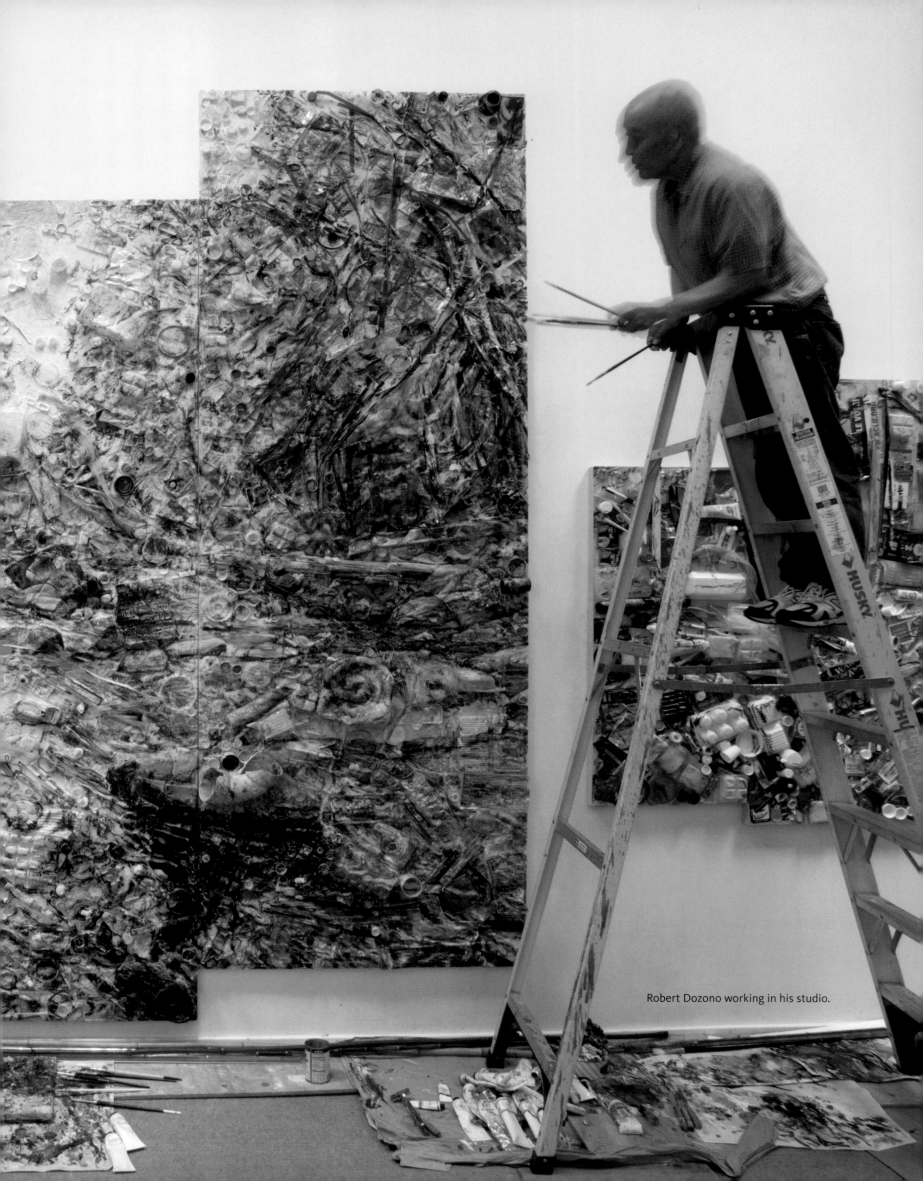

Robert Dozono working in his studio.

VISUAL MAGIC
An Oregon Invitational

Artist Statements and Current Cities of Residence

Susan Applegate (born 1944)
Yoncalla, Oregon

I am always seeking ways to describe the relationships between objects and the space they occupy. Each place contains latent emotional forces I am interested in exposing. I look for pathways to wed both negative and positive space exploring the inner vision within each scene.

This painting is inspired from a series developed during a residency at the Morris Graves Foundation in northern California. There, a dark mysterious lake reflects the deep green forest both above and below the inky water's surface. During a great earthquake some seven hundred years ago, a crevice opened, swallowing portions of the surrounding mountains. Over time this basin became a lake. The dead and petrifying trees captured debris, forming little islands. It is a place whose beauty is haunting. I was inspired to render this sense of the lake's quiet moody beauty as well as the potent natural forces that made it.

Being true to the scene I am painting is being true to my emotional response to it. Trying to hold on to the "vision" and my emotional response is always a struggle between what is there and what is felt to be there. This conversation back and forth between what I see or what I recall and the stirring emotions experienced is what eventually forms the painting.

I often use *plein air* work, meditation and memory, bringing what I paint in the studio into a closer approximation of the original inspiration.

At "The Lake" I worked during the full moon, in strong sunlight as the breezes pushed the chartreuse duckweed from one end of the lake to the other, and under arching rain showers.

Jay Backstrand (born 1934)
Portland, Oregon

Well-respected Oregon artist Jay Backstrand creates powerful and enigmatic paintings. He eloquently juxtaposes such disparate elements as an Asian rubber toy next to an art historical reference next to ambiguously cropped archaic symbols. His work pulls the viewer into an abstruse and unique mapping of diverse times, people, and experience. Connecting to our subconscious and contemporary society's ceaseless exposure to images of all kinds, his assemblages seem ironic and prophetic. He deftly samples from a variety of stylistic and intellectual contexts, making work that compels repeated looking and often prompts more questions than answers. Backstrand studied at the Pacific Northwest College of Art, where he later taught art from 1975-1986. He also studied at the Slade School in London as a Fulbright fellow. He has exhibited his work since the 1960s, and in the 1970s was a co-founder of the Portland Center for Visual Arts. In 1984, he was honored with a ten-year retrospective at Marylhurst College, OR, and more recently was included in *Living Legacies: JSMA at 80* (2013) at the Jordan Schnitzer Museum of Art, University of Oregon. His work resides in the collections of the National Gallery, Washington, DC; the Oxford University Press Print Collection, England; the Portland Art Museum; the Seattle Art Museum; the Tacoma Art Museum; the Henry Gallery at University of Washington; and Hallie Ford Museum of Art at Willamette University, Salem, OR. He has been the recipient of various awards, including the Honorarium Award at the Fourth Annual Mayor's Oregon Artist Series in Salem, OR, a NEA grant, and several purchase awards.

Statement provided by Russo Lee Gallery, Portland.

**Unless otherwise noted, each statement was provided by the artist in 2018.*

Robert Bibler (born 1948)
Salem, Oregon

I think of my drawings and paintings as acts of investigation, and the imagery often suggests contemplation. I utilize a realist approach to explore relationships between images, between what can be regarded as material or concrete in a drawing or painting and the inference of something symbolic or spiritual. I'm interested in the tension between significations of the present and the residue of the past.

The traditional Renaissance "window" space of pictorial illusionism fascinates me, and my work has often made reference to it. Renaissance allusions or visual "quotations" are a frequent motif, presented ironically, symbolically, or paradoxically "in a post-modern context," as one critic put it discussing my drawings.

The compositions feature an interest in the forms and details of human anatomy combined with ordinary and discarded objects, fabric, glass and reflections, water, and shadows. These are arranged often with some surrealist spatial dislocation or narrative whimsy to become a still life about time, or a mythological art history event, or to suggest an imaginary "film still" about perception and consciousness.

I have exhibited artwork professionally since 1974, participating in solo and group exhibitions. I was a member of the Blackfish Gallery in Portland for eight years, and was represented for several years in Seattle by the Kurt Lidtke Gallery and then by the Mary Lou Zeek Gallery in Salem. I was a finalist for the 2015 Portland Art Museum's Contemporary Northwest Art Awards. My drawings and paintings are held in several collections, including the Bonneville Power Administration, the City of Portland Visual Chronicle Collection, The Frederick and Lucy Herman Foundation Collection of Drawings at the College of William and Mary in Williamsburg, Virginia, the Home Builders Institute in Washington, DC, the Maryhill Museum, the Jordan Schnitzer Museum of Art, the Hallie Ford Museum of Art, and the State of Oregon Historical Properties, and several college and university collections. My work is in private collections in the Pacific Northwest, California, New York, Pennsylvania, and Minnesota.

Sharon Bronzan (born 1943)
Portland, Oregon

The paintings in this exhibition are narrative studies. I have tried to create landscapes in which the figures are protected and at ease with the world around them. The work frequently references mythology and archetypes addressing vulnerability and strength.

In each of the paintings represented, the figure is given "tools" to negotiate life. In *Shaman's Skirt* I depicted a skirt on which the natural world is reflected in the animal and plant pattern of the fabric. The skirt at once protects the figure and gives her power.

The title of the painting *Body Guard* is a play on words. The alligator, due to its beastly appearance and reputation, could be seen as the figure's "body guard." The alligator in a different set of circumstances could be seen as life threatening. The figure in the painting is wearing a coral cape. In many cultures it is believed coral has protective and curative powers. The coral cape in this situation is the "body guard." The woman is undaunted by the alligator.

The painting *Butterfly Effect* was inspired by the work of Edward Lorenz and the founding principles of chaos theory. The effect grants the power to cause a hurricane in China to the flapping of a butterfly's wings in New Mexico. In other words, small changes in an initial condition can create drastic changes in the results.

In a small town in Mexico people see butterflies as souls, and it is to that town that Monarch butterflies migrate each year on or around November 1, the holiday known as the Day of the Dead. The returning butterflies are seen as the souls of the deceased. *Visitor* is a meditative piece referencing my personal story of a visit to Mexico for Day of the Dead.

My relationship with the natural world is influenced by myth, folklore, and religious iconography. These influences and the timeless practice of storytelling allow me to give order to a world I find chaotically complex.

Sandy Brooke (born 1947)
Bend, Oregon

There is an element of chance in every painting, often a surprise, an unexpected outcome, but there are no accidents. Meaning I work with intent, I am directed by a sense of space. I am headed somewhere that will materialize out of the process I have developed to put paint on the canvas in layers. I always liked what Milton Resnick, an abstract painter, said when asked, "How do you go about painting? What's your technique?" To which Resnick replied, "I have no technique, I just put paint on and let the paint do the talking!" To that end, these paintings are composed of many thin layers of oil paint over calligraphic lines of graphite. I add paint but often I subtract it wiping areas off that aren't working.

For a hundred years modern art has questioned the function of art and its relationship to human life. Nature balances between beauty and chaos; art and life depend upon each other constantly interacting. The subject of these paintings is the recent demise and melting of the Arctic. The titles of the paintings are the names of channels, fjords, cities, and oceans in the Arctic Circle. The Arctic is geographically complex with very complicated weather systems. The once solid sheet of ice has reached an all-time low and has fractured, separating into large icebergs floating as giant sculptures toward the Atlantic Ocean. This is concerning when you consider just one effect. The Greenland ice cap, for example, contains enough water, were it to melt, to raise sea levels globally by around twenty-three feet. That seemed concerning to me and enough so that I spent two years investigating or grappling in the paintings with the possibilities of climate change in the Arctic.

Clint Brown (born 1941)
Corvallis, Oregon

In Greek mythology, Cerberus, a three-headed dog, guards the gate to hell; in this painting it is defending the path to the bedroom from religious and governmental intrusion. The geometric shapes suggestive of the domestic setting are deliberately compressed, like a shallow stage setting, and the figures are like actors in a stop-action drama. The dog and cat are symbols of domesticity that disturb the iconic symmetry of the composition and emphasize a play on the idea of conflicting interests.

I have to acknowledge the influences of many other artists whose work I admire. In particular, the geometric compositions of Richard Diebenkorn's *Ocean Park* series and the narrative images of Eric Fischl, the expressiveness of Francis Bacon, and my longtime love of Pierre Bonnard's use of color. The abstract formal issues are important to me, and at the same time I want to make an image that is on some level a social narrative and emblematic of this age and our human nature—ideally an image that is more than decorative and can hold its own as an icon in a world inundated with computer animation and special effects.

Karen Carson (born 1943)
Venice, California and Big Timber, Montana

I spend my summers in Montana ranch country and have grown fond of the colorful tractors, swathers, balers and other farm equipment that animate the rural countryside. I have painted several large (9 x 12 feet) images and during their exhibition I was surprised to find that people in cities apparently really love tractors. They have them in their pasts. So I did this series as a tribute to these great big, sexy machines. I chose to present them affectionately in what has been called, historically, Action Painting.

Craig Cheshire (born 1936)
Portland, Oregon

Painting always is engrossing to me because every new subject presents challenges that I haven't encountered before, even after more than sixty years of making paintings. It is as if every subject requires me to become a beginner and to experiment my way through. That is how it is for me.

I always have been attracted to places where human hands haven't interfered much, if at all. *John Day Country* is this sort of subject. The area has been farmed for well over one hundred years, but the cliffs and canyons towering above haven't been fazed. They remain aloof and inscrutable.

Margaret Coe (born 1941)
Eugene, Oregon

I love being included in a group show with the words "visual" and "magic" in the title because I view painting as a magical realm. Generally, I have regarded efforts to demystify art as a mundane denial of mystery and beauty. It seems ironic that while I think I am uninterested in the contemporary obsession with conceptual, political, or identity-based art, I choose to exhibit a painting that is all three. Although it is a rare thing for me to start a painting with a full concept in mind, that is exactly what happened in *True Crime (The Borghese Case)*.

I imagine that a popular mid-20th century crime magazine features a story on the abduction and rape of Proserpina. This crime is witnessed daily by thousands of tourists in Rome's Borghese Gallery, but it goes unrecognized as a felony because the characters within the marble are so damned beautiful. Yes, visitors are seduced by the artist's visual magic. Bernini created a Pluto that is handsome and virile. Viewers can easily regard the abduction as almost consensual, or see it as an inevitable act of nature. The victim does not bite or scream. She barely resists. Only his hand pressed against her stone flesh suggests the pain this girl will endure. Surely this is a symbolic image.

Furthermore, I imagine Bernini's triumphant predator to be symbolic of the alpha male mentality in an ancient civilization, one that is proud of its moral code and its fear of the Gods. Were religion and honor primary values in their thinking, or superficial beliefs, while the real operational values were brute force and survival of the fittest?

The Greek word *Plutos* means wealth and plutocracy. The Romans considered Plutos "the giver of gold and other precious metals." But the most famous act of this "giver" and God of the Underworld was the rape of a young girl, an act that transforms him into a useful symbol for the radical capitalism and exploitation of nature that plagues us today. Perhaps religion functions as an effective salve to whitewash our own brutality.

Jon Colburn (born 1934)
Salem, Oregon

A few years ago I began to see the venue of art as a subject. In this light I made the place of showing, the gallery, the movie screen, or the stage part of the work itself. The paintings I make are now painted as paintings in a gallery. The action becomes the action in a movie and the figures are put on a stage.

Modern daily life has become more vicarious and more self-conscious. Our lives are scenes that are played out continuously in cascades of media. It is more difficult now not to see everything we do and experience as something in a scene or script that makes up the play that we are living.

Bets Cole (born 1951)
Elmira, Oregon

I have spent most of my career as an artist traveling and painting throughout the US and Europe in the *plein air* tradition. In the open air I study the ever-changing landscape, recording both its vastness and its details. Recently, I have chosen to reexamine and investigate my subject matter more closely in the studio. I spotlight specific moments and characters that played a significant role in my experience of a particular place and time, creating intimate vignettes that are approximately the size of postcards. I am amazed at how much emotion, memory and expressiveness I can convey through markmaking and the manipulation of color and shape on this scale.

My work can be seen in the collections of Oregon State University, University of Oregon, Umpqua Community College, Marathon Coach, The Adell McMillan Collection, and M&T Investment Group in Baltimore, MD. I was an artist-in-residence for the 100th anniversary of Crater Lake National Park and was awarded the Maryland Institute College of Art's five-week Isabel Klots Artist Residency in Rochefort-en-Terre, France. My work has been showcased in the Governor's Office in the Capitol Building in Salem, as well as in a number of books.

Jon Jay Cruson (born 1943)
Eugene, Oregon

My drawings, prints, and paintings have been inspired by observing landscapes for over fifty years. Abstractions of the intricacies of nature are the basis of my work.

Robert R. Dozono (born 1941)
Milwaukie, Oregon

The natural environment is very important to me. All these years I have reused objects that one cannot recycle – plastic items without numbers, wiper blades, rubber bands, toothpaste tubes, hair dryers, etc., into my work. The rivers and their unfortunate interaction with humans are evident to me when I go fishing with my friends. Sometimes we try to carry out garbage that others have left. Many of my paintings are large river scenes of the Clackamas River and other areas of Oregon. I attempt to foreground what we are doing to our natural resources by using a canvas layered with what is normally cast aside.

I grew up in a world where no one wasted anything. I had one pair of canvas tennis shoes and when they wore out my father and I went to a store and bought another pair. I grew up in a world where no one used paper or plastic bags. Everyone wrapped everything in newspaper: fish, vegetables—everything. Nothing was wasted.

No trash was in the street because everything was reused. Cans were reused to make toys or other useful items. I used them to play kick the can with my friends or tied strings to them to walk with, making sounds like a loud horse. I made airplanes, kites and fishing poles using bamboo we cut. I caught bugs for bait using layers of spider webs on a wire ring tied to a long bamboo pole.

I have had no regular garbage service for over 27 years. Once or twice a year I have garbage pick up the items that I cannot recycle, compost, or put into my paintings. I shred all yard debris and put them back into earth. In those 27 years, I've been recycling my own garbage into my paintings. Nowadays I am happier because I can recycle more items using curbside pickup so I don't collect as much garbage in my studio to use in my paintings.

I still feel uncomfortable for having too many shoes, shirts, cars and too much fishing equipment. I have a difficult time throwing things away.

I think we don't respect or take enough responsibility for our natural environment. In this age and economy, it is almost impossible not to waste. I almost wish that we could return to a time where no one wasted and reused everything.

Robert Gamblin (born 1948)
Portland, Oregon

I am a painter and also a manufacturer of artists' colors. I think of myself as a colorist. To me a colorist might or might not use strong color; rather they understand the emotional contents of color and use color as the most important expressive element in their work.

Every oil color has a unique set of qualities and carries a clear emotional message, I have learned this well from having made so much color over my career. All the technical knowledge about color I have learned is the foundation I stand on as a painter in the studio. This understanding is my confidence, and that confidence sets me free to call into play my intuitive relationship to color as emotion.

I have painted several series of paintings based on cities that I love. The series on Amsterdam was chosen for *Visual Magic*. Besides being a great city with world class museums, Amsterdam has played an important role in the history of oil painting. It was here during the 17th century that oil painting found a market for the first time among the secular class, much like it has today over the whole world.

Also, part of my attraction to Amsterdam is that it is a city built on a system of canals. The light of the sky reflects off the surface of the canal water, thereby lightening the visual weight of the scene. This is in contrast to most cities where the streets are dark and heavy looking. I am always attracted to the motif of light reflecting off the plane of the earth whether it is a canal, pond, river, lake, or sea.

In Amsterdam I feel the past, the Golden Age of Amsterdam, and simultaneously all around is modern Amsterdam with all its awareness of contemporary thought and design. These themes are invited into this work; each painting is keyed to one color that embodies an important aspect of either contemporary or old Amsterdam: Brown and Delft Blue for the old, Prussian Blue and Vermillion for the contemporary.

Humberto Gonzalez (born 1944)
Portland, Oregon

From a very early age, I found drawing to be a fascinating and magical way to record an observation. Line and color are the elements which hold my interest and give form to my participation in art. Watercolor is the most natural vehicle in which to exercise this visual interest. The medium's characteristics of nuance, transparency and immediacy contribute further to complement my chosen approach. Drawn directly from field work, my paintings are studies which reflect the spirit of the subject as well as the nature of the painting process. A painting may begin with the subject as the focus of observation but as the work evolves, it is the painter's visual dialogue and his decisionmaking process that lead to an internalizing of the moment. The singular act of painting on site with its myriad influences is synthesized to create a personal, tangible reflection of the creative experience. The paintings are a visual diary of my expressed response to specific places, persons, or things at a given point in time.

I am inspired by the dramatic diversity of the landscape. It is impressive to note its power to color one's sense of perception and its capacity to influence our emotional base. As a painter, these notions motivate my curiosity and energize my work. The landscape offers an array of colors, textures, shapes and forms. To strive for good composition is always the challenge. At a specific, selected site I search for large areas of color, patterns of repeated elements, activity of surface planes or the directional thrust of gestural forces in the lay of the land.

Painting directly from nature is about paying attention. Keen observation can earn the right to interpretation and transformation, ways of seeing which can lead to creative exploration of the measures and relationships which abound in the natural world.

Humberto Gonzalez was born in Mexico, and immigrated to the United States with his family at the age of 10. He studied at Northern Illinois University in De Kalb, Illinois, earning a BA in Art and Spanish Literature, and then a MA in Secondary Education with an emphasis in Art. He moved to Oregon to teach Spanish and Art from 1971 until his retirement in 1999, at which time he returned to painting full time. He was a friend of the late Nelson Sandgren, and a regular at the annual Oregon coast painting outings Sandgren organized. Gonzalez exhibits his watercolors frequently throughout Oregon and beyond, has won numerous awards in juried group shows, and has served as a juror for OSU's Art About Agriculture exhibit three times. He has been showing with Karin Clarke Gallery since 2004.

Dennis Gould (born 1940)
Noti, Oregon

I aim to make each work a voyage of discovery. Starting with no subject or end goal in mind, it is interesting to me to see where the making of the work will take me. Where will my mind go and what will the process of working suggest? What paths, what apparent subjects? To do this, a work often starts with a splash of paint or ink. Unplanned, as best as it can be. The work begins as I interact with the mediums and follow the course they suggest. Sometimes the work will take many months and some will be completed in several weeks. A work is finished when all the possible outcomes of a work are considered, accepted, or rejected. I like the finished work to be a surprise, in a way. It is my wish that the viewer will share the discovery of something too.

Cie Goulet (born 1940)
Emeryville, California

Coming from a printmaking and painting background, Cie Goulet reinvestigates landscape with contemporary immediacy. In her prints and oil paintings, she is drawn in particular to the visual dynamism of landscape and the possibilities for visual excitement. Though often working from photographs or rough sketches, she has relied a great deal upon direct experience and imagination, with sole concerns for the sensuality of composition and a sense of place. These landscapes are not always meant to replicate a specific geographical location, and often challenge the landscape genre and expand our perception. At the same time, the transcendence of light energizes these works, and calls into play emotional responses, such as warmth, nostalgia, and familiarity.

Goulet studied at the San Francisco Art Institute, University of Oregon, and the Parson's School of Design. Her work has been exhibited on both the West and East Coasts in such galleries as the Louis Meisel Gallery, the Artist Space, the Hansen Galleries in New York, the San Francisco Art Institute and the Jenkins-Johnson Gallery in California, and the Russo Lee Gallery in Portland, Oregon. She was also featured in the exhibitions *Ray Trayle: Prints from the Legendary Presses* at the Hallie Ford Museum of Art and *Wonder Women at the Art Gym*, Marylhurst University, along with various others. Her work is in numerous public and private collections, including Bank of America, Delta Airlines, Federal Reserve Bank, Hilton Hotel Corporation, Microsoft Corporation, Oregon Health and Sciences University, and the Portland Art Museum. She currently lives and works in the Bay Area.

Statement provided by Russo Lee Gallery, Portland.

George D. Green (born 1943)
Oak Grove, Oregon

My pictures are painted using multiple systems of pictorial space. Mainly, I combine horizon seeking perspective with shallow space *trompe l'oeil*. This creates a very believable illusion which doesn't break down, even when the picture plane is touched.

If you're reading this, you are probably seeing these pictures in reproduction. And, *trompe l'oeil*, when seen in reproduction, is like a ventriloquist on the radio (a less than spectacular event requiring great trust). So please spend time watching these in person and touch the surface whenever possible.

I like combining exuberant, gestural fat paint with precise, high definition *trompe l'oeil* and heartbreaking, cornball romanticism. And if the paintings turn out to be ironically beautiful ("pretty as a picture"), so much the better.

Aside from all this, many of these pictures appear to be carefully planned. They're not. There is never any particular plan or goal—no pre-determined expectation. Each painting is its own surprise.

This process is very nearly a direct path into the intuitive mind. It's a lot of automatic activity and for sure, no judgments permitted while in flow. Only full speed ahead. It's a painterly dive into a zone where all stuff is discoverable and most things allowed.

Yes, I realize some will see this only as a personal opinion—untested by scientific rigor. But this is not the case. I have a bachelor's degree in science from the U of O and through many years of personal experimentation and research, I know all this to be true. It's the science of the angels.

Artist's sidebar: All these pictures are hand made without photography or advanced technology.

John Haugse (born 1937)
Santa Barbara, California

I was once told by a Portland gallery owner that he'd love to show my work, but thought Portlanders would feel uncomfortable with the intensity of my Southern California colors.

"Mute them," he suggested.

So, it's odd in a way that the painting selected for this show of Oregon artists has the most intense colors I think I've ever used. Predicting how people will respond to one's work is folly.

So then, how to write about visual imagery? What is true today is often untrue tomorrow. My Master's thesis attempted to show a relationship between the subject I was painting and the style or general "look" of the final painting. Now, fifty-five years later, I'm still wondering what I meant by that.

The truth is much simpler. Art is fun. It's the great adventure of my life; it's the reason I laugh more than cry at the condition of the world. Without restraint or value or judgment or awards or honors or any of it. Art is joy. I was set on my path by my high school art teacher and mentored by great teachers along the way. Now, after nearly six decades of studio work, I am still entertained and amazed and in love with the daily ritual of standing in front of my easel and squeezing paint out of a tube.

Carol Hausser (born 1949)
Salem, Oregon

I paint with transparent watercolor, a notoriously unforgiving medium, which produces on paper luminous, evocative, yet indelible stains. Despite the risk, I do not plan my paintings or their meaning. I start with a shape or two, and then continue to add shapes as I observe how things are coming together, what the tone is, and how I can elaborate on the visual language that I have started. I work to build a painting by juxtaposition of movements, color, and through compositional decisions. Then I strengthen, adjust, and moderate the competing elements I have orchestrated to construct a solid, unified painting from there. By repeated rinsing of the entire painting, drying, and then repainting, I remove any build-up of surface pigment, producing paintings that appear lit from within. Transitions, dark shapes and areas of saturated color are typically rinsed and repainted carefully many times until the desired qualities are established. I rely on my nerve and on an earned belief in my painting skills.

My typical subject might be described as mysterious, transitory movements that suggest passages through time, thought, and experience. My process is meditative, and so philosophical/spiritual concerns reveal themselves to me as I paint. As one critic reviewing my work wrote, "These paintings present variations on a theme of intricate inner spaces, of thoughts dissolved and reformed in the process of making." Abstract illusionist shapes are comingled with improvisational mark-making to evoke a visual journey with shifting perspectives, unexpected connections, passageways, and unravelings. Spatial ambiguity and paradox are recurring themes, often depicted in a spiraling universe of uncertainty, elusive phenomena, and irreconcilable forces.

My paintings are in the Microsoft Art Collection, the Hallie Ford Museum of Art, Oregon Percent for Art and the Chemeketa Community College art collections, and have been exhibited at the Sawhill Gallery at James Madison University, the Portland Art Museum, Tacoma Art Museum, Frye Art Museum, Coos Bay Art Museum, Jordan Schnitzer Museum of Art, the Arts Center in Corvallis, and in many group shows in the Pacific Northwest. I was represented in Seattle by the Lynn McAllister Gallery and in Salem by the Mary Lou Zeek Gallery.

I spent most of my childhood in Montana where I was lucky enough to attend a high school that had a dynamic art program. After I left Montana, I earned a BA in Art at the University of Washington in Seattle in 1971, followed by graduate study at the University of Oregon in 1979-80. I am married to the artist Robert Bibler and we have lived in Oregon since 1973.

Jeri D. Hise (born 1946)
Oak Grove, Oregon

These paintings draw from our shared art historical past and my own personal narrative. They are oxymoronically both old fashioned and newfangled. Slamming these disparate images together in juxtaposition creates new, multi-dimensional layers of insight and mysterious meaning, simultaneously. Each image separately carries its own aesthetic charge, but when placed together a new and entirely different energy is created.

George Johanson (born 1928)
Portland, Oregon

Autobiography and portraiture are strong aspects of my work and have been the focus of various series of mine over the years.

In this painting, *Studio with Bunce Mask*, I am drawing a line profile of my granddaughter, Sonja. The mask in question is a plaster life-mask of Louie Bunce, which hangs on the wall of my studio. Louie was my first painting teacher at the Museum Art School, and a life-long friend and mentor.

Leland John (born 1939)
Portland, Oregon

This is a variation on several of many paintings done at Rocky Creek, a few miles north of Newport, on the central Oregon Coast.

I must thank Nelson Sandgren from Oregon State University and his son Erik Sandgren for introducing me and so many others to magnificent painting sites along the coast.

Kacey Joyce (born 1947)
Eugene, Oregon

Through my artwork, I endeavor to encourage a mindfulness in the viewer – an appreciation for the beauty, value and vitality of the ordinary.

Connie Kiener (born 1945)
Portland, Oregon

My primary interest is in the beauty of all things universal and the importance of our connectedness to everything. The forms and images I use in my ceramic work range from the things of the natural world to manifestations of human endeavors as expressed through the art forms of a variety of cultures and my own eye.

I hand-build and paint on a wide range of ceramic sculpture and vessels as well as wall pieces expressed in relief, mosaic, tile, or a combination thereof. My independent study of the Maiolica ceramic glaze and painting technique in Deruta, Italy has determined the bulk of my creative endeavors. I took what I absorbed from Italian techniques combined with my studies at the California Institute of the Arts and made a process of my own, which explores the relationship between form and surface with clay, glaze, and paint.

A Portland native, Connie Kiener studied at the Museum Art School, Portland, OR; the California Institute of the Arts, Chouinard Art Institute, Los Angeles, CA; and an independent study of Maiolica in Deruta, Italy. Her work is represented at the Russo Lee Gallery, Portland, OR, and is part of numerous public and private collections, including the Renwick Gallery, The Smithsonian Institution, and the White House in Washington D.C., the Arizona State University Museum, Phoenix; the Arkansas Decorative Arts Museum, Little Rock; the Racine Art Museum, Racine, WI; the Hallie Ford Museum of Art, Salem, OR; the Regional Arts & Culture Council (RACC), Portland, OR; and a ceramic installation at the Oregon Convention Center in Portland.

Statement provided by Russo Lee Gallery, Portland.

Edwin "Ed" Koch (1937-2018)
Last resided in Bend, Oregon

Edwin Koch was born in 1937 in Missoula, Montana. At the age of 18, he moved to Portland, Oregon where he began his artistic journey studying for two years at the Portland Art Museum School. After attending Rhode Island School of Design for three years (1958-61), he was drawn back to Oregon where he received his B.S. in Painting and Drawing at the University of Oregon. In 1964, at the age of 27, Edwin returned to school where he received his M.F.A. in 1969, once again through the University of Oregon.

Edwin Koch was a realist. Some described his style as Super Realism. In his words, "Through the use of oil on apple wood panels, I strive to use classical values to guide my picture-making decisions such as objectivity, formality, balance, simplicity, dignity, restraint, and austerity. I think that my paintings should be able to speak for themselves, especially when my art form is of such an explicit nature. Words are superfluous. It is the nature of the painting that it should exist independent and separate from its creator. What is key to understanding me as a realist aesthetic painter is the word combination, reducing the infinity of possibilities to a desirable and meaningful single expression."

When he realized he earned less than $4.00 an hour, he changed how he priced his work. With his usual precision, he clocked himself in and out of his studio, increased his wages per hour, and priced his paintings accordingly. He died in May 2018, having lived his life as he painted—simply, bluntly, and realistically. The epitome of this was when a family member asked him how will we know when you die, to which he replied, you won't. To the further question, what if you lie there for a week, he replied in his simple, straightforward manner, "I won't care; I'll be dead."

Statement provided by the artist's family.

James Lavadour (Walla Walla) (born 1951)
Umatilla Reservation, Oregon

Every morning I walk to the studio before the sun comes up. Ten years ago, on that walk, a meteorite streaked overhead and lit everything like day. It was a terrifying and wonderful moment. Painting is that same experience. The bits and details of that flash of brilliant clarity would pass by if not for the practice of painting. A painting is a structure for the extraordinary and informative events of nature that are otherwise invisible.

Painting is not about making pictures, rather it is a transfiguration of energy from one state into another. Painting is a model that allows us to examine the infinite in our physical reality. It is a process that is happening in real time where every micro-space of surface holds something to discover. Image is merely a framework for these cosmic events made visible. I use the horizon of landscape, middle ground, and foreground because they are what I know from years of hiking and observation of the land around me. Everything that is in the land is in me. There are rivers and mountains in paint. A simple brush stroke is the universal undulating flow, always in motion and ever informative. Painting is a structural record for time and space. In my view the whole purpose of modern painting, and art in general, is to dive into the unknown and to bring back those gems of knowledge and wisdom that are beneficial and uplifting. Art, science, and technology form the spectrum of the human reflective faculty the same way that red, yellow, and blue are the refraction of one light. This is how we become educated and informed.

I am a self-taught artist. My art education came from the land. I learned through endless walking, looking, hearing, and feeling the natural world around me. Also I learned from music, reading every art magazine I could get my hands on, and most of all from the act of painting itself. As in, the music of Miles Davis and John Coltrane, the paintings of the Chinese literati and the work of the Abstract Expressionists, improvisation is the spark for my inquiry.

Statement provided by PDX CONTEMPORARY ART, Portland.

Nancy Gilbert Lindburg (born 1934)
Salem, Oregon

My work reflects an unabashed love of color and surface richness. In moving from large canvases of textured color-fields to intimate works on paper or canvas depicting the most simple of objects, I am seeking to express what is beyond the literal. That, for me, is the fundamental mystery and joy of art.

BA, Mills College 1956; MFA, Cranbrook Academy of Art, 1958. Painter, teacher, arts administrator, and life-long arts advocate. Executive Director, Salem Art Association 1973-78; Artist Services Coordinator, Oregon Arts Commission 1978-91, where she managed the Percent for Art in Public Places Program; 9 solo exhibitions and numerous group exhibitions; 1995 Oregon Governor's Arts Award; 1993 Tribute to Outstanding Women Award, Salem; 1977 Award for Excellence in the Arts, Salem.

Margaret Matson (born 1943)
Santa Barbara, California

While living in a Canadian "Chinatown" working on a sculptural project for the Canadian Government I was fascinated to discover, tucked somewhere in every neighborhood grocery shop, the many carefully made objects created in paper, intended for burning at the death of a beloved to provide in the afterlife a facsimile of a needed item, delivered in smoke.

I was equally fascinated by the ephemeral quality represented by the intense labor that was destined to be so quickly reduced to ash.

In California in the '90's my response to the racial explosion in Los Angeles was to create a set of "Los Angeles" ("the angels") sculptures that were steel and burned wood figures, in elaborate paper dresses... an evolution in my appreciation of my Chinatown curiosity. *Sister Dress* is one in a series of explorations and forms that I now periodically revisit. It is a form that provides a lengthy meditation as I experience my own response to our human expressions of culture, industrious focus, and life's joys, simultaneously comprehending that our very existence is so utterly fragile and vulnerable.

Sue-Del McCulloch (born 1944)
Salem, Oregon

Growing up in Eastern Oregon in a time and place of remarkable freedom was formative in learning my love of nature and landscape. Crossing the mountains, I found along the way the vital teachers and mentors who stimulated, guided and encouraged me: Laverne Krause, Carl Hall and Robert Hess most significant among others.

Most of my life has now been lived in the Willamette Valley. My paintings are the landscape of home. Here in this carved-wide valley, held in the generous hug of the Cascades and Coast Ranges, the farmed fields ride the layered hills, sidling up mountains that thrust into the enormous sky.

In my work, I employ a vocabulary of value using light and dark as a metaphorical language. Light itself organizes the land, creating its shifting forms. These abstract forms coalesce into specific representation of atmosphere, time and place in the local landscape. At some level, many of us still respond to landscape, seeming to retain a longing for that connection, an echo of our ancient place in nature.

Spring in Clover Time is of the field across my road, usually planted in wheat, here planted in a crop of crimson clover. It is a joyful metaphor itself for it is a nitrogen binding plant that is used to renew and replenish depleted soils. It blooms for a short period in the spring. I'm always on the lookout for it in season as it isn't planted in the same place twice. In its opulent concentration of color, it holds intense dark in its depths. It is almost difficult to discern its color when looking directly into its vibrating mass. Its light areas become nearly too tame, shifting into an old rose pink. It is best viewed in early morning or evening, allowing its heart of darkness to remain, underpinning the relief of the light.

It is a challenge to paint, to convey anything convincing about its strength and intensity as well as its improbable color, holding the knowledge of its ability to restore a patch of earth in its exuberant beauty.

That spring, the skies were a dramatic match for the crimson fields in their wild, heady color concentration: filled with clouds bearing a heavy mass of moisture and particulates carried from distant fires and agricultural processes, they revealed the architecture of the very air in its great shifting structures.

Gary Meacham (born 1939)
Silverton, Oregon

I paint what I see, with the best of my ability.

Terry Melton (T. R. Melton) (born 1934)
Salem, Oregon

I paint, I write, and remain solidly engaged in such things. The adventure is unrelentingly challenging as well as enigmatic. I relish the chases each day along with a five o'clock martini.

BA, Idaho State University, 1959; MFA, University of Oregon, 1964; Paintings, prints, drawings in more than 50 solo & group exhibitions; Works in collections of Boise Art Museum, Colorado Springs Fine Arts Center, Hallie Ford Museum, Missoula Museum of Art, Yellowstone Art Museum, Portland Art Museum, Salt Lake Art Center, Jordan Schnitzer Museum of Art. Art catalog essays, visual arts criticism, poetry published and administrative positions with arts organizations and government. Awards: Montana Arts Council Governor's Arts Award, University of Oregon Achievers, Idaho State University Professional Achievement Award.

Kenneth O'Connell (born 1945)
Eugene, Oregon

Sketchbooks are the notebooks of artists. Rarely are they dated, numbered, or is a location noted. They contain random rough sketches and notes, often made with pen, pencil, watercolor, or markers. I approached it differently.

I started my first sketchbooks in 1961 with my teacher Larry Goldade. In 1962 David Foster suggested I number these sketchbooks. Robert James suggested this was a portable studio to work in on the go. Jack Wilkinson suggested that I use his system of "Separate, Part, Combine, Contradict" as a way to analyze ideas.

These were powerful teachers and sort of Zen Masters in their own way.

Sketching, drawing, and writing are fundamental ways of thinking for me.

For 57 years I've been working in sketchbooks. During the same time I worked in experimental and animated film, photography, ceramics, printmaking and painting.

When I teach workshops I show people how to use the Sketchbook to explore their own imagination and their process of seeing and exploring the world.

Paula Overbay (born 1940)
Brooklyn, New York

I imagine nature at a cellular level: molecules as a metaphor. Everything about our environment is a whirlwind of activity in which we are only a small part. This natural energy that I seek keeps the weather cycling, resides over growth in Petri dishes and changes our consumed bread into cells. Our world is in constant flux and I am interested in the elements of exchange from one cell to another that are as common as breathing and as mysterious as the stars.

The dots represent this world of throbbing particles as mass, line and pattern. Moving dots smoothly from one element to another represents the transference of energy and remains one of the most important formal considerations to resolve each time. The journey starts from a single point and continues into color masses that coalesce and disintegrate like the murmurations of birds or run in long strings like beads and curl into snails. The many dots turn into form.

Lucinda Parker (born 1942)
Portland, Oregon

I've been leaning towards mountains for the past few years, with the old god of abstraction hovering over my shoulder to remind me to get those long diagonals, big shapes, conjoined triangles right!!

I'm not done with cubism yet, just dragging it outdoors to boost my eye up higher. Consider overlaps, fractured rocks, sheer slides, crumbled columnar basalt, the whole rhythmic jostling mass which must be transposed within the four sides of my canvas. Melting ice, wrinkled old snow, Mt. Hood like an old lady in a shabby bathrobe, still catching ecstatic morning light. You want to learn how to look? Try painting her.

Statement provided by Russo Lee Gallery, Portland.

Janet "Jan" Reaves (1945-2018)
Last resided in Eugene, Oregon

A Northwest artist, Jan Reaves received her MFA from the University of Oregon in 1983. She taught art throughout the Northwest and was on the faculty of the University of Oregon from 1988 until her death in 2018. Reaves' work was exhibited frequently over the past four decades in numerous group exhibitions regionally and nationally, including exhibitions at the Portland Art Museum, OR, The Art Gym, Marylhurst College, OR, The Seattle Art Museum, WA; Western Michigan University, Kalamazoo, MI; St. John's University, Jamaica, NY; San Jose Institute of Contemporary Art, CA, and others. In recent years she was included in *The Long Now* at the Jordan Schnitzer Museum of Art, University of Oregon, and in *Landscape*, a contemporary survey of regional painters at Linfield College, McMinnville, OR. Reaves won various awards including the Juror's award for the 2001 Oregon Biennial at the Portland Art Museum, and purchase awards from the Oregon Arts Commission, the Regional Arts & Culture Council, Portland, OR, and the Oregon Health & Sciences University, Portland, OR.

My work searches for what is elemental in an experience. The sheer joy in the quiet acts of observation and speculation feeds and propels my work in the studio. My paintings and drawings explore ideas about the body and the natural world through the language of gesture and materiality. The images negotiate the edge between representation and abstraction. The ovoid, elliptical forms in the work function as primordial, non-denominational elements: carriers of meaning, similar to the metaphoric use of words in language. The shape could be a wheel, a moon, a head, a lethal projectile or a letter of the alphabet, depending on its location within the constructed narrative of the painting. A cognitive shimmer happens when the image triggers a memory or recognition in the viewer. This shimmer occurs just prior to understanding, distinct from the comprehension that we associate with naming. To name is to fix our understanding. I would like to momentarily suspend the viewer between the "recognition" and the "fixing."

Statement provided by Russo Lee Gallery, Portland

Laura Ross-Paul (born 1950)
Portland, Oregon

The two paintings selected for *Visual Magic* are bookends of my current painting exploration. I have had a long-term interest in depicting the figure in mystical and psychologically compelling environments, often employing the use of symbolism. The current exploration of different painting materials allows the mixing of both ephemeral and energetic elements; oil covered watercolor for *Hot Hands* and sumi ink and iridescent acrylic on mineral paper mounted on a rice paper scroll for *Under Water*.

In *Hot Hands*, a young boy is embedded in a colorful, nondescript background, his forearms and hands a fiery red-orange. The painting asks the question: what has reddened his hands? Are they bloody? Are they on fire, as the painting's title suggests? Symbolism compels the viewer to use their own experience or interpretation to answer these questions. I was prompted by a tingling in my hands and a desire to connect the hands and eyes creatively through the brain when I conceived this piece.

Water has always been a subject of fascination for me. Recent trips to China have compelled me to explore sumi painting on mineral paper, mounted on rice paper and presented as a scroll. In *Under Water* two swimmers, a male and a female, swim away from each other, while also swimming away from an iridescent oval ring of water above them. Did they enter the water together? What is their relationship? Capturing the light patterns that water makes was a huge challenge. I am thrilled that *Visual Magic* displays this work in a scroll format, rather than framed under glass, as this is a presentation method I am quite interested in continuing to explore.

Sandra Roumagoux (born 1940)
Newport, Oregon

The painting *Spring Run* is one from a series of paintings titled *Tires in the Landscape* that I completed during the last three years. Environmental concerns remain as my subject matter. Most of my paintings are oil on stretched canvas, plywood or heavy paper that has been gessoed. Work ranges in size from 72 x 84 inches to 22 x 28 inches.

For the past several years I have returned to my roots as a landscape painter. Rather than using figures in the landscape to present a point of view, I have been using the land itself. Lincoln County's clear cuts, discarded tires, bays and estuaries and general land use have been my subject and focus.

My political interest extends beyond the studio. On December 31, 2018, I finished serving my third term as the Mayor of Newport, Oregon. While I have been and continue to be sincerely committed to my avocation as a policy maker and civic leader, it's also true that I see elements of social practice art making in my life as a politician.

The painting *Spring Run* is my reaction to the ubiquitous covering of the land with discarded tires. Go for a nature walk off the beaten path and under the low growing growth of Salal, huckleberries, blackberries, ferns and grasses one can often find a hidden ground cover of tires. If the tires found in the landscape are a legitimate part of the flora and fauna, how would their habitat be portrayed? The tires in the painting *Spring Run* take the form of a fishery returning to spawn.

My work is a continuation of my development as a painter of oils. I am as enthralled with oil paint today as I was 50 years ago. I made the decision many years ago to ignore the edict that painting was dead. I keep thinking that if I live long enough, I'll learn how to paint. I use oil in the *alla prima* method. After my composition is on the canvas, I work all over the surface trying to bring the painting to a finished state with one pass of the brush. I start my paintings from observations of the landscape and then in the studio I improvise with "what if" questions.

Erik Sandgren (born 1952)
Portland, Oregon

I bring to the landscape a set of modernist traditions and material practice. The natural milieu of the Pacific Northwest returns to me its mystery, history, power and nuance. Skill sets acquired by early acquaintance with Northwest artists were further honed at Yale College, constant practice and a deep familiarity with the work of artists throughout history. A resonance with Northwest subject matter has been furthered by the imagery and philosophy of classical Chinese painting where the changeability of water interacts with the relative fixity of rock. Here on the Pacific Rim I have been a painter of the Rain Coast—from California to South East Alaska, British Columbia and out to Haida Gwaii. Elements of the observed landscape co-evolve towards something both imagined and remembered. The master trope of my work comprises human references subordinated to the encompassing rhythms of nature.

Isaka Shamsud-Din (born 1940)
Portland, Oregon

I was born in Atlanta, Texas, in 1940 to tenant farmers. We moved to Vanport, adjacent to Portland, Oregon, in 1947 after an attempt on my father's life. My family was among the 19,000 residents evacuated from the Vanport Flood in May, 1948. I'm one of fourteen children. My work is buttressed by those rural beginnings and my personal activism and involvement in some of the most significant movements and groups during the '60s and '70s: the Student Nonviolent Coordinating Committee, Black Arts West Repertory Theater, the Black Panther Party (San Francisco) and the Nation of Islam. Amiri Baraka (LeRoi Jones), Kwame Toure (Stokely Carmichael), Bobby Seale, Emory Douglas, Ed Bullins, Congressman John Lewis and Marion Barry, SNCC's first chairman and former mayor of Washington, DC were friends and associates.

Over the past 50 plus years I chose to focus my art to illuminate, educate, commemorate, document and inspire. To relate African, African American and African Diaspora experience. In historical and contemporary contexts, personal narratives, portraits, murals and editorial cartoons were created to address the great void of the Black experience.

I retired from Portland State University Department of Art in 2006 after serving as the first James DePreist Professor in Ethnic Art through an endowment established by Harold and Arlene Schnitzer, to whom I am eternally grateful for their unwavering support of me and my family through some of the most difficult years of my life and my career.

Robert Colescott was one of my instructors ('63-'65), and Jacob Lawrence helped dedicate my Bilalian Odyssey mural at the Justice Center in Portland, OR in 1983. I've been artist in residence and instructor at San Francisco State U., Reed College, Pacific Northwest College of Art and other schools. I want to leave physical proof that African people exist(ed) here.

Jim Shull (born 1935)
Silverton, Oregon

The most important "statement" is the actual work of the artist. While I like to make images (statements), mostly by drawing and painting, there are other reasons, such as a need to make visual statements of interest to me that become, sometimes, of interest to others. We can call these visual statements Art.

In the introduction to **The Story of Art** (1950) the art historian E.H. Gombrich said, "There is no art, only artists."

What artists do is make all sorts of "art things," which can be social and/or political, realistic or abstract. They can be interesting, sometimes significant, occasionally relevant and often irrelevant to others, but not irrelevant to the artist.

My "art things" are drawings and paintings. While I can say that I draw or paint what I observe, a larger concern is drawing or painting what I'm thinking, and that includes drawing or painting to find out more about what I'm thinking.

"There is no art, only artists" seems to be a tautology: "art is what artists do," a true but redundant statement that is not very informative.

I have some personal views about this situation—

For the last five hundred years attempts to get art nailed down to firm and irrevocable rules or standards have had limited success (and it's still going on). Every generation has an avant-garde of, maybe, revolutionary artists that manage to get some of the rules changed, usually just in time for the next generation and another batch of changes to the rules. A situation of permanent change, which seems to be happening faster these days, too fast for some and not fast enough for others...

For the guardians of the status quo, changing the rules is often taken to mean the destruction of art and all that is good and beautiful. For the avant-garde, changing the rules is the restoration and/or renewal of art, and all that is good and beautiful. Maybe we can conclude that there are no rules, but that could imply that art is an undefined pursuit, or activity with no purpose, "anything is art," which amounts to "nothing is art." So why bother? To answer that is to ask why do we bother to stay alive? There are lots of reasons for living, including doing things that we call art...

Moved from Arcata, CA, to Salem, OR, 1948. Attended University of Oregon as art major, 1954 to 1963, BS and MFA. Taught art and other courses at Mt. Angel College, 1964 to 1973. Taught photography and graphic design, Treasure Valley Community College, Ontario, OR 1977 to 1978. Worked as graphic designer, builder and installer, SEE Design and Production, 1978 to 1989. In 1989, started Interpretive Exhibits Inc. (with three other owners), as president and graphic designer, retired July, 2000. Still painting...

Susan Trueblood Stuart (born 1938)
Salem, Oregon

As I stand in the dynamic presence of a landscape, infused with its own spirit, my eyes seek out the drama in shapes that oppose each other, that set up contrast, energy, and action. The great teacher, Nature, turns me toward red, and ocher, toward steel blue and green, colors singing with aliveness.

From the primordial energy, now flowing between my body and the body of the earth, an image becomes imprinted on the paper. My unconscious dialogue with the creative power begins and I pull an image out of the paper, reveling in the forces of *re*creation.

Watercolor gives me the speed and freshness I need when I paint outside. Acrylics offer me richness and depth. Both ignite the excitement I feel when the plains of a belly turn into the sensuous curves of a hillside, or when the vigor, motion and force of water impregnate a human form.

At some point, what is outside of me merges with what is inside. And the miracle of a living landscape, of space and light, of texture and form, embraces all I know or have ever known. And in that moment, I am truly alive.

Richard Thompson (born 1945)
Dayton, Oregon

When asked about my work I say something like "…I paint what I see and what I think about what I see."

Catchy, professorial… zen-ish… arty…

But, of course, between you and me, I am not often sure what I am seeing and, well… thinking clearly about what I'm seeing is always a problem.

Somedays, I see one way and think another and, then the next day, I see another way and think something else.

This seeing/thinking/seeing/thinking thing I can sometimes work out with a brush… sometimes… often… well sometimes…

Hugh Webb (born 1940)
McMinnville, Oregon

The more absurd I get, the older I become. This, I have discovered, is due to a syndrome often found in American males called Puberty Stagnation which is defined as "a difficulty in maturing." Having looked into this in therapy I believe that I have not progressed much beyond fourteen years old. I think some of this is due to an over exposure to such things as Mad Magazine, Spike Jones and Stan Freberg. Later there were the Grateful Dead and Miles Davis, and while one would not exactly label these two absurd, they did introduce me to the idea of extensive improvisation.

Many fine teachers spoke eloquently about composition and structure, but like most 14 year olds, the idea of following the rules didn't hold much appeal and in true teenage fashion I figured I'd do the opposite. Then one day I discovered a quote by the author Henry Miller who said, "Paint as you like and die happy." The dying part wasn't especially appealing, but the paint as you like part sounded great.

The great thing about improvisation is that there are few, if any, limits and you never know where you are going to end up. Also, as a practical matter, every painting works out. You just keep adding stuff until you feel that's enough – i.e. no wasted paint.

All too often humor in art is condescended to or considered unworthy as "serious" subject matter. I hope that the viewer will allow the absurdity of the work to trigger their own fantasies and imaginations and perhaps create a story of their own. Or, lacking that, perhaps just appreciate the colors or let the picture provoke a sense of wonderment.

Hugh was purportedly educated by the finest professional minds at Oregon State University and the University of Oregon earning an MFA degree in Painting leading to a teaching career of 35 years at various colleges and a professional career of over 35 Solo exhibitions, over 125 Juried/Group shows; winning cash and purchase awards. His work is in many private and public collections including Microsoft and The Smithsonian.

Phyllis Yes (born 1941)
Portland, Oregon

I love to garden, to watch the evolution of a seed pushing up from the earth, turning into leaves, flower buds, and then glorious flowers. It's magic. The colors, textures, scent, and power of a flower cannot be matched. Put them in a clear glass vase and it makes my heart beat faster. How fascinating to see the refraction of stems as seen through the life-giving water. It is my intention to try to capture all of this in a simple and colorful manner.

When I receive flowers for a special occasion, I want to capture it so that it lives on for years to come.

Ken O'Connell's sketchbooks

Published by
Jordan Schnitzer Museum of Art
1430 Johnson Lane
1223 University of Oregon
Eugene, Oregon 97403-1223
541-346-3027
jsma.uoregon.edu

This publication and the accompanying exhibition were made possible with support
from Coeta and Donald Barker Changing Exhibitions Endowment, Arlene Schnitzer
and Jordan Schnitzer, the Oregon Arts Commission and the National Endowment for
the Arts, a federal agency, JSMA Members, the Ford Family Foundation, and generous
private donations from the George D. Green Art Institute's Benefactors and Sponsors.

Based on the exhibition *Visual Magic | An Oregon Invitational*, January 19 - May 12, 2019,
Jordan Schnitzer Museum of Art, University of Oregon, curated by Danielle M. Knapp.

ISBN 978-0-9995080-5-3

Jill Hartz & Danielle M. Knapp, Editors
Mike Bragg, Designer
Printed through Four Colour Print Group

Photography, unless otherwise noted, by Jonathan B. Smith and Annie Bunch (JSMA)
or provided courtesy of the artist.
Additional photography provided by:
Gary Alvis, Studio 7 (2, 26)
Aaron Johanson (Cover, 25, 35, 48, 51, 76)
Jim Lommasson (64, 66, 67)
Scott McClaine (55)
Steve Steckley (70)